How to Draw & Paint

Fairyland

LINDA RAVENSCROFT

BARRON'S

A QUARTO BOOK

First edition for the United States, its territories and dependencies, and Canada published in 2008 by Barron's Educational Series, Inc.

All inquiries should be addressed to:
Barron's Educational Series, Inc.
250 Wireless Boulevard
Hauppauge, NY 11788
www.barronseduc.com

ISBN-13: 978-0-7641-3953-6
ISBN-10: 0-7641-3953-3

Library of Congress Control Number: 2008923839

QUAR.HDPF

Conceived, designed, and produced by
Quarto Publishing plc
The Old Brewery
6 Blundell Street
London N7 9BH

Project editor: Trisha Telep
Art editor: Natasha Montgomery
Designer: Karin Scånberg
Copy editor: Ruth Patrick
Additional text: Sheila Coulson
Art director: Caroline Guest
Picture researcher: Sarah Bell
Proofreader: Helen Maxey
Indexer: Diana LeCore
Creative director: Moira Clinch
Publisher: Paul Carslake

Color separation by Sang Choy International Pte Ltd, Singapore
Printed by Star Standard Industries (PTE) Ltd, Singapore
9 8 7 6 5 4 3 2 1

Contents

Introduction 6

Chapter 1

Getting started **8**

Monochrome media **10**

Watercolor and gouache **12**

Acrylic paint **14**

Other useful media **16**

Transferring an image **18**

How colors work **20**

Painting flowers and foliage **22**

Fairyland weather **24**

Circle of the seasons **26**

Using color to create mood **28**

Chapter 2

Picture making **30**

Gathering fairyland
inspiration **32**

Keeping a sketchbook **34**

Composition and viewpoint **36**

Cropping and scale **38**

Ready-to-draw file:
Sacred fairy places **40**

How to Draw & Paint
Fairyland

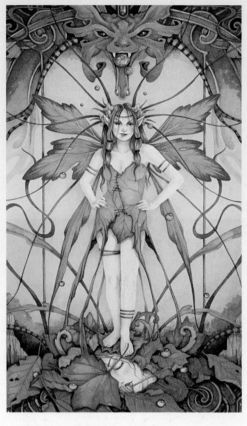

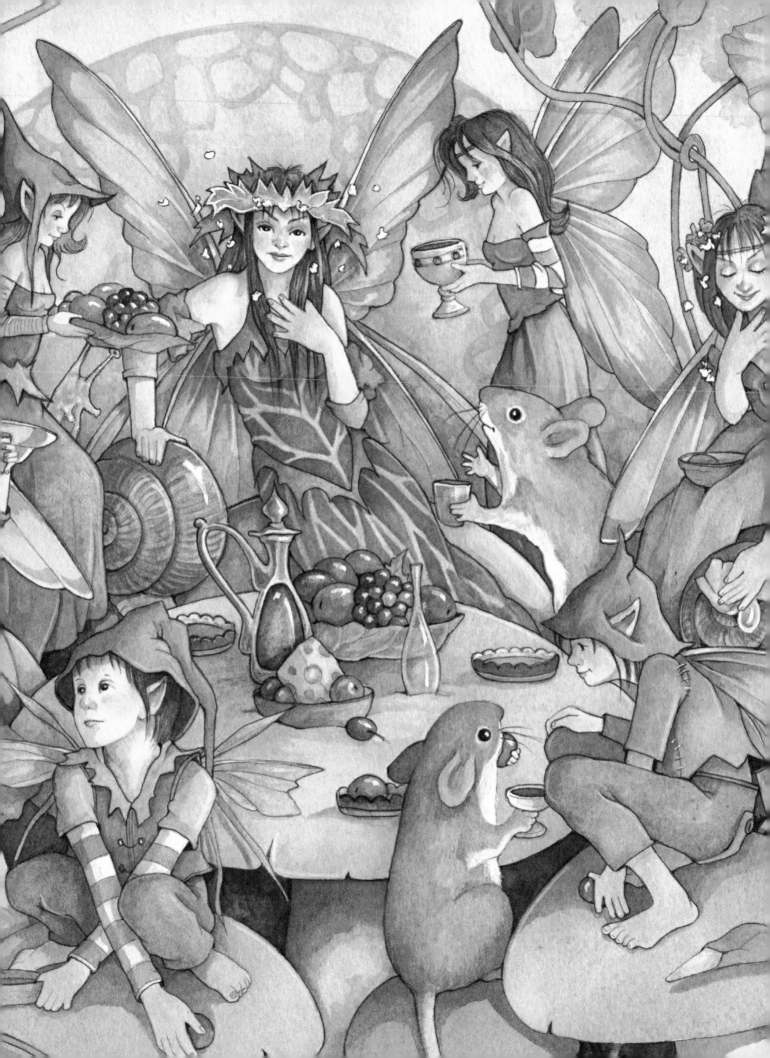

Simple perspective	**42**
Foreshortening	**43**
Ready-to-draw file:	
Fairy friends	**44**
Light and shade	**46**
Ready-to-draw file:	
Home sweet home	**48**
Creative ideas and	
transformations	**50**
Ready-to-draw file:	
Fairy neighborhoods	**54**

Chapter 3
Inventing fairyland **56**
Core techniques	**58**
Nature's details	**62**
Trees	**62**
Leaves and foliage	**64**
Frosty leaves and	
winter branches	**66**
Fruits and nuts	**68**
Berries	**70**
Flowers	**72**
Magic in the air	**74**

Rocks, stones, and water	**76**
Reflections	**78**
The man-made world	**80**
Wood fences and	
stone walls	**80**
Fairy environments	**82**
Castles in the air	**82**
Thrones in ice castles	**84**
Castles in fairyland	**86**
Underwater	**88**
Rainforests	**90**
Fairy tree homes	**92**
Mushroom villages	**94**
Fairy groves	**96**
Fairy bridges	**100**
Sacred stones	**102**
Advanced project:	
A midsummer feast	**104**

Chapter 4
Gallery **110**
Ready-to-draw file: Figures	**120**
Index	**126**
Credits	**128**

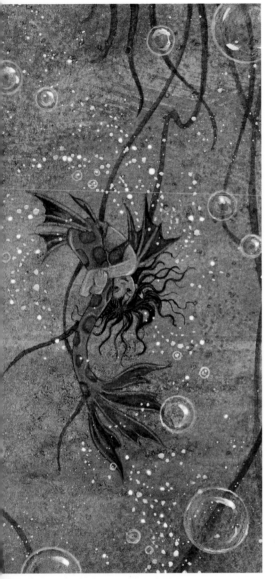

Introduction

Everyone's idea of fairyland is unique, and that's exactly the way it should be. Maybe you have dreams of mile-high trees in endless, magical fairy forests, or vivid images of fairy villages shrouded in pretty fairy dust. Fairyland is as individual as each imagination. It's your unique vision, with perhaps a little inspiration from the art you'll find in this book, that will make your fairy art special, personal, and unforgettable.

Legends of fairyland and the "wee folk" (or "good folk," or "people of peace"—the euphemisms are endless!) trace back thousands of years. There were stories told to us as children about prank-playing fairies tangling the hair of sleepers into "elf-locks," and words of warning about avoiding fairy rings and ancient oaks for fear of stepping into fairyland, never to be heard from again. It's no wonder we have a fascination with fairies and their complex, magic-filled world.

Although there is no actual proof of the existence of fairyland itself as a physical place, for some of us there is no doubt. It is as real a place as the world around us, and nurtures our hearts and dreams with the fun and innocence of children. For those who aren't quite sure if they believe in fairyland, this book should help you find it!

Create an underwater fairy habitat on pages 88–89.

Step-by-step drawings show the progression from tracings to realistic fairyland landscapes.

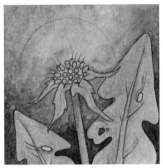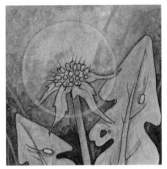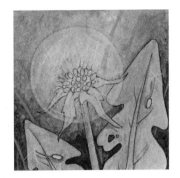

Add magical elements to fairyland with the simple use of color and line.

Human beings are the only known creatures on this earth capable of expressing their imaginations in the form of art. It is truly a wonderful gift, and should be used at every opportunity. Whether you want to create a fairyland full of mischievous fairies and the neighborhoods in which they live, or a more contemplative, nature-oriented fairy sanctuary, I hope that the projects in this book get you into the mood to create some truly original art. Fairy art is the perfect genre in which to express your imagination and sense of fun!

Shine brightly,

Linda Ravenscroft

Fairyland is about details (see Berries, pages 70–71).

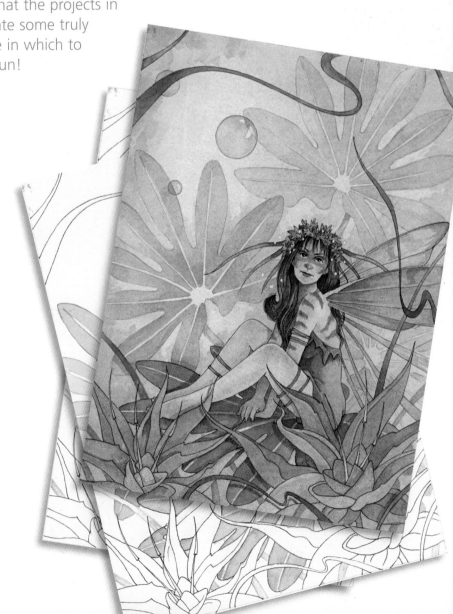

Chapter 1
Getting Started

Make sure that you have all the right equipment before you start!
This chapter covers all the important materials needed for whatever
type of fairyland painting you decide to do.

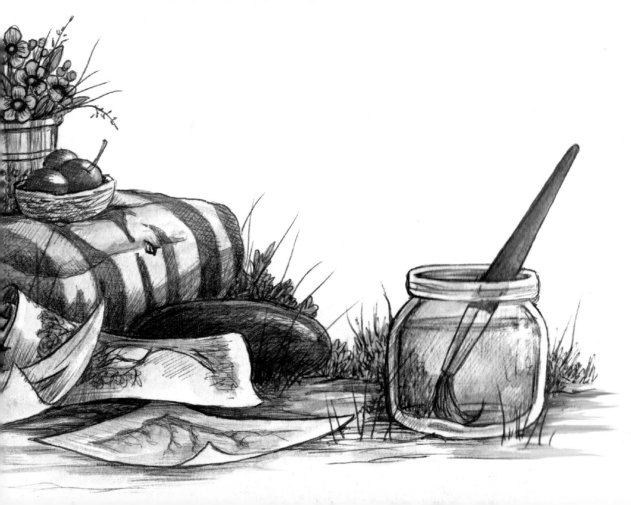

Monochrome media

A monochrome drawing is one that is made with a single color—it could be any color, though most often it's black. Graphite pencils and ink pens are the most frequently used media for monochrome work. Both create an astonishing variety of marks and subtle tonal effects that help convey mood, texture, and light. You can use them for exciting and expressive finished artwork, or to create underdrawings before adding color. Moreover, both media are light, portable, and ready to use, so they're perfect for your sketching kit. Try out the varied effects that pencils and pens can create—you may decide to incorporate both in your work.

Starter kit

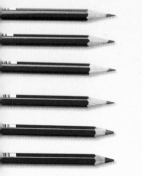

- You need a range of pencils that gives you plenty of line and tone options. The combination of HB, B, 2B, and 4B makes an ideal first pencil kit. You could add H for fine details and for tracing, and include a very soft 6B if you like to add really deep tones.

- A pad of good quality sketching paper
- Plastic erasers and soft putty erasers
- A craft knife and sandpaper block
- Fixative

Graphite pencils

Graphite pencils are by far the most popular tools for creating monochrome drawings. They're inexpensive, easy to use, and tremendously versatile. They can produce anything from the finest gray lines for intricate details to broad sweeps of intense dark tone for quick sketches.

Types of graphite pencils

Graphite pencils range from very hard to very soft, indicated by letters and numbers. The H range is hard and the B range soft, and in each range the higher the number, the harder or softer the pencil. Thus 9H is extremely hard and 9B very soft, while HB is an all-purpose, mid-range pencil. Hard pencils retain their points for intricate lines and precise details. Soft pencils produce darker, velvety tones and wonderfully varied and expressive lines. Graphite is also available as thick sticks graded in the same way as pencils. These are exciting to use for bold lines and broad areas of tone, but are unsuitable for fine linework.

Accessories for pencils

- Pencils need frequent sharpening. Avoid pencil sharpeners that produce short, fine points that break easily. Instead use a craft knife or scalpel to shave off the wood and sharpen the graphite gently. You can rub the point on a sandpaper block as you work to maintain the tip.

- An eraser is essential—or ideally two. A soft putty eraser lifts out highlights and blends tones, and an all-purpose plastic eraser removes mistakes without roughening the paper surface.
- Fixative protects your drawings from smudging, especially ones made with soft graphite. Make sure you choose an ozone-friendly product.
- Keep spare sheets of paper on hand to cover and protect your drawing as you work.

Papers

Use almost any type of paper for graphite pencil work. Good-quality, smooth sketching paper is perfect for both fine, well-defined marks and for broader lines and softer areas of tone. Pastel papers are slightly textured and produce less crisply defined marks and attractive surface effects. These are available in a wide range of subtle colors. Cold-pressed watercolor papers have a more pronounced texture that breaks up pencil marks to create interesting tonal effects.

Pencil marks

A single pencil makes a huge range of tones, marks, and lines, depending on the pressure you use. A 2B, for example, can produce quite fine lines, or darker marks and swaths of shading. Use an HB for establishing shapes and to make preliminary drawings for paintings; use a 2B for soft, subtle tones and more emphatic lines. Choose a soft 6B for dark marks and solid black areas.

Pencils and their marks

Soft versus hard	Expressive lines	3D form	Gradations	Pencils as dry pigment
Soft pencils produce dark marks (left), while hard pencils produce light gray marks (right).	Use the edge and point of your pencil to inject expression into your lines.	When drawing 3D forms, it should feel as if the pencil is moving over the 3D object, not flat paper.	Best created using a soft pencil, starting with darkest values. For large areas, use the side of the pencil.	Create large gradations by shaving a graphite stick to produce powder. Apply with fingers.

Pens

Pen-and-ink is ideal for delicate drawings, but art shops stock lots of alternative types of drawing pens, too. They can all make exciting contributions to your work. If you're new to pen drawing, experiment to see how each type feels and performs. Remember that a pen line is a more or less fixed width, so marks are less varied. However, there are plenty of pen and nib sizes to choose from and you can combine several in one drawing for their different effects. Remember, too, that pen marks are permanent, so the only way to correct mistakes is to draw over them—work lightly at first to get things right before you commit to more emphatic marks.

Types of pens

Traditional dip pens have interchangeable nibs. The flexibility of the nib and the flow of ink help to create varied and expressive marks. Similarly, reservoir pens have nibs of different widths. For line drawings, use permanent inks; for line-and-wash effects choose water-soluble inks.
Ballpoint pens, roller balls, technical pens, and fine-liners deliver a regulated flow of ink from inflexible tips that don't deteriorate, so lines remain constant. They come in various widths so you can introduce different weights of line into your drawing. Use very fine lines to suggest distance, and heavier lines to advance the foreground.
Fiber-tipped pens and markers have many styles of tip, from fine points for details to broad bullet or chiselled tips for large areas and bold marks. Some conveniently combine both options in one pen. Some are water-soluble for wash effects and color blending.

Papers

Smooth, drawing paper or hot-pressed watercolor paper is best for pen work. Avoid absorbent and textured papers that will clog up your nibs and cause fiber-tipped pen marks to "bleed" and soften. Always protect your work surface with a spare sheet of paper under your drawing when using fiber-tips. For water-soluble pens you'll need hot-pressed (smooth) watercolor paper that won't buckle when you add water.

Starter kit

- Most pens are easy to use and inexpensive, so go for a couple of nib-widths in each category and see how they suit your style of drawing.
- Pad of smooth sketching paper
- Hot-pressed watercolor paper for water-soluble inks
- Watercolor brush and water pot for wetting water-soluble inks

Flexible nib dip pens
In various widths, these are great for mark-making with ink.

Inking pens
Marker pens that create extra-fine lines are invaluable for detail work.

Pens and their marks

Ink and wash

Create a full range of values using waterproof ink on paper. Once it's dried, go over the drawing with ink washes to establish midtones.

Ink and paintbrush

Vary your brush-stroke pressure to control line width. Experiment with brushes for new textures: soft rounds, stiff-bristle flats, filberts.

Dip pens

Dip pens create irregular lines that convey a strong sense of movement. Use different textures of paper for interesting variations.

Ink wash with highlights

Establish a full-value range with ink washes, then add white chalk or gouache highlights to simulate the look and feel of underpainting.

Technical pens

Uniform line width, continuous ink supply, and ease of use make technical pens appealing. Vary line direction and spacing for effect.

Unusual marks

Scribbles, dashes, or blotches may often work far better than lines. Experiment with brushes, pens, sticks, clothes, or feathers.

Watercolor and gouache

Watercolor and gouache are popular media for fairy paintings. Both can be diluted in thin, wet washes to create subtle tonal gradations. Applied more thickly, they create areas of solid color and add fine lines and intricate detail. The essential difference is that watercolor is transparent, while gouache is opaque. Each has its own unique possibilities, but they complement each other, too.

Watercolor

Loose washes applied in various ways produce subtle whispers of color for mysterious and ethereal fairy backgrounds. Thicker mixes give more intense colors. In true watercolor the only white used is the white of the paper. You work from light to dark, leaving light areas unpainted and building up the darker areas gradually. The white of the paper shines through transparent washes with a delicate luminosity that's unique to watercolor.

Types of watercolor

Students' watercolors are inexpensive, give good results, and are ideal for a starter kit. Artists' colors are made with better pigments and are more expensive, but worth considering as you gain experience and confidence. Both are available in pans or tubes. Pans fit into paint boxes with built-in palettes —convenient for working outdoors. Tubes contain soft paint that's better for stronger mixes and thicker opaque techniques. Both come in boxed sets, or you can buy them singly and create your own selection.

Papers

Watercolor papers are available in different weights, but are always strong enough to support wet washes without crinkling. They come in three finishes: smooth, "hot-pressed" (HP) paper, cold-pressed paper with a slight surface texture, and "rough" with a pronounced texture. Cold-

Paper types

You can see the degree of texture on rough handmade paper (1), rough machine-made (2), cold-pressed papers (3 & 4), and hot-pressed smooth papers (5 & 6).

pressed is a good all around paper, but experiment with all three to see the effects they create. Buy single sheets or pads and choose white or very pale cream.

Brushes

Round brushes are a good all-purpose choice for laying washes, creating broad swaths of color and sweeping lines, and for working fine, linear details. They are available in a wide range of sizes. The best brushes are sable, but synthetic alternatives are cheaper and perform well. Consider trying a rigger with a long, narrow head that creates long, fine lines more easily than a round brush, plus a flat brush to lay down washes and broad lines quickly.

Accessories for watercolor

Mixing palette is essential. These are available in a range of styles. Ceramic palettes are less likely to stain than plastic, but both are easy to clean. The number and size of the wells is a matter of personal choice and convenience.
Masking fluid is a useful addition. Paint it onto your work to reserve areas of white without having to paint around them, then rub it off when the work is finished and dry.

Starter kit

- Watercolor pans or tubes (see "A starter palette" on page 21)
- No.2, No.4, No.6, and No.9 round, all-purpose brushes
- Cold-pressed watercolor paper
- Mixing palette
- Water pot
- Masking fluid
- Kitchen paper, tissues, or toilet paper for lifting out mistakes

Using watercolor in fairyland

Lost-and-found edges	Feathering	Letting color in	Mottling	Layering	Glazing
fairyland use: **hills**	*fairyland use:* **trees**	*fairyland use:* **flowers**	*fairyland use:* **branches**	*fairyland use:* **backdrops**	*fairyland use:* **textures**

Wet paper. Add wavy stroke of color above wet area. Carry color down into wet. Allow to bleed down. Dry.

Make two water lines. With mix of two colors, brush two parallel lines at right angles to water lines.

Make water patches on paper. Load a brush with paint and touch it to the edge of the wet patches.

Paint squiggly lines with a two-color mix in an interlacing pattern. Spatter water over the lines.

Paint a flat wash in any shape. Paint another within. Do it once again. Not more than three layers.

Paint three bands of color with flat brush. Dry. Paint a band of one color across the top. Continue.

2

4

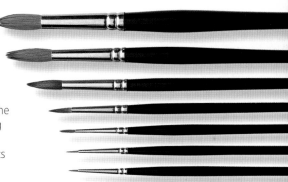

Brushes

Buy the best brushes you can afford—natural bristle or synthetic, in a variety of sizes.

Gouache

Gouache can be diluted like watercolor to create subtle semi-transparent washes and fine details. Used thick, it is opaque, and you can even use it undiluted to create wonderful textural effects. Because it is opaque, gouache covers well—so, unlike watercolor, you can work from dark to light, adding lighter areas last, and even covering up and correcting mistakes. And because you can paint light colors over dark, it's useful for adding highlights to watercolor paintings.

Types of gouache

Gouache is sold in tubes, pans, and pots, either in boxed sets or singly. The range of colors is enormous, especially in tubes, but with a few carefully chosen basics, or a beginner's boxed set, you can mix almost any hue.

Paper

Watercolor papers, especially cold-pressed ones, are perfect for gouache. However, because you can work from light to dark, you can use colored or handmade papers, so your choice is limited only by your imagination. Just make sure the paper you choose is heavy enough to support layers of wet washes.

Brushes

Watercolor brushes are fine for gouache, especially all-purpose round ones. If you want to apply the paint thickly for surface textures, use bristle brushes in sizes suitable to the areas you are covering.

Media for watercolor and gouache

Media change the way watercolor and gouache behave, and create some exciting effects that are worth exploring. *Oxgall* is a wetting agent that keeps washes open and enables them to flow more freely on the paper. Add it to the wash or use directly on the paper. *Texture media* contain small particles that create a texture on the paper, while an iridescent medium gives a pearly glitter effect that's perfect for fairy subjects. Try metallic gouache for a touch of magic, or scatter common salt onto wet paint for a magical, crystalline effect.

Starter kit
• Gouache tubes: buy a beginner's set (or see page 21, "A starter palette")
• Brushes: choose a selection of round watercolor brushes
• Cold-pressed watercolor paper
• Mixing palette
• Water pot
• Kitchen towels

Inks and watercolors

Get used to a standard palette of colors in both watercolors and colored inks before adding more.

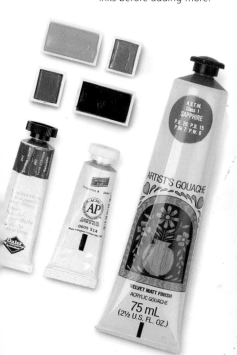

Using gouache in fairyland

Thin gouache

If you mix gouache with water, you can simply apply it as you would watercolor.

Thick gouache

Mix gouache with less water for a thicker paint that will dry opaque and matte.

Wet-on-dry

Work thick, wet gouache over a dry area. The crisp brushstrokes will hold their shape and color.

Light over dark

Thick, opaque gouache lets you layer light colors over dark, dry ones (unlike in watercolor).

Torn paper

Instead of masking fluid or film, use torn paper with gouache for a unique edge.

Acrylic paint

Acrylic paints combine many of the features of watercolor and oils, but have their own unique qualities. They can be applied thickly like oil paints in layers of vibrant color. Diluted with water, they create delicate washes or glazes. They cover well, dry quickly, and are completely waterproof and permanent when dry. This means you can build up rich layers of color quickly and paint over them with watercolor or gouache without fear of the colors mixing with the acrylic beneath. You can draw over dry acrylics with pastels, colored or graphite pencils, and crayons for a range of exciting possibilities.

Types of acrylic paint

Here again you have a choice of students' or artists' colors. Students' acrylics are less highly pigmented than artists', but are perfectly adequate colors with which to start. Artists' acrylics cost more and vary in price according to the pigment used. Thick acrylics are available in single tubes or pre-selected sets. Liquid acrylics are more suitable for delicate washes and are available in small glass pots in a dazzling array of intensely pigmented colors—a little goes a long way. A limited range of basic colors is available in plastic bottles.

Paper

You can use acrylic paints on a great variety of supports. Traditional watercolor papers are a good place to start. Once you've got the feel of the medium you can also try cardboard, hardboard, wood, or canvas (none of these require priming first). If you choose one of these kinds of supports, make sure it is grease-free or it will resist the water-based acrylic.

Brushes

The choice of brushes for acrylic work depends on the techniques you'll be using. Use soft watercolor brushes for washes and delicate details. Use stiff bristle brushes for techniques that use thick paint. There's no need to buy expensive brushes to start with—there are perfectly good synthetic versions of both soft and bristle brushes that will do the job well. Buy a small selection of sizes, depending on the scale of your projects.

Starter kit

- Acrylic paints, tubes, or liquid: beginner's set (or see "A starter palette," page 21)
- Brushes: a selection of round watercolor brushes, plus a small bristle brush for thick paint use
- White or tinted cold-pressed watercolor paper
- Mixing palette
- Water pot
- Retarding medium

Using acrylics in fairyland

Wet-into-wet

For watercolor-like effects, thin the paint and apply to wet paper or canvas. The thicker consistency of acrylic will not flow like watercolor, but the look will be similar.

Flat wash

Acrylic paint has a uniform, matte finish, and even the most opaque color will be a bit translucent, allowing you to build up colors and values gradually in layers.

Lifting out

Interesting effects are created by lifting out color while it's drying, with paper towels, sponges, or cloth (especially on canvas and nonabsorbent grounds).

Impasto

Thick, undiluted acrylic can mimic the look of oil paint, allowing an application with a stiff brush or palette knife to create impasto or alla-primalike effects.

Accessories

- Acrylics dry out very quickly when exposed to the air. Keep them moist, on a plastic or ceramic palette, by spraying the paint regularly with water. Clean the palette while the paint is wet—once it dries it will be impossible to remove. Alternatively, invest in a stay-wet palette designed to keep the paint moist and workable for several days, or buy a pad of tear-off paper palettes suitable for acrylics (simply tear off the used palette at the end of a painting session and throw it away).

- A retarding medium is useful to slow the drying process of your paint and allow you more time to mix and blend your colors right on the paper.
- Other media are available for acrylics that create a variety of effects. Look at gloss and matte media that alter the natural eggshell finish of the dry paint, or try texture gels and modeling pastes to create surface interest.

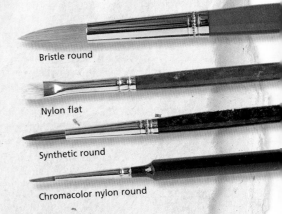

Bristle round

Nylon flat

Synthetic round

Chromacolor nylon round

Rich colors

Acrylic paint offers a rich palette of color. White highlights create 3D flowers.

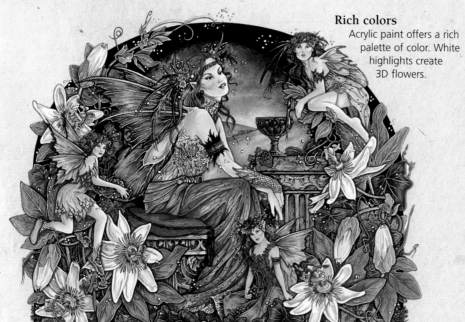

Brushes

All types of synthetic- and natural-fiber brushes can be used with acrylic paints. Buy a variety of brushes to make different marks, including soft bristle brushes for thin, fluid washes, and stiff bristle brushes for the thicker applications of paint used in techniques like impasto.

Tubed acrylics

Acrylics are a portable, versatile, and satisfying medium worth mastering.

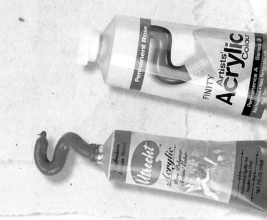

Palette knife

The faster drying time and thick consistency of acrylic makes thick applications with a palette knife possible, to create very textured, thick, and luscious paint layers.

Adding texturing agents

Texturing agents like thickening gels and sand can be added to acrylics (if they contain no oils), to create a range of effects that bond permanently with the paint.

Dry brushing

Wipe most paint off your brush. Once the brush is mostly dry, drag it across the canvas. Paint adheres to the "peaks" of the textures, to allow colors beneath to show.

Glazes on distressed paint

Bring out the scrapes, scratches, and textures in your painting by experimenting with glazing areas with very fluid paint that will settle into the depressions created.

Other useful media

There's a mouth-watering array of interesting media available in most art shops. Some are traditional, and some are new discoveries that add an extra creative dimension to existing products. Many of them offer exciting possibilities for creating delicate and atmospheric fairyland paintings. Most are available singly and in boxed sets, so experiment with a small selection first before you invest in a comprehensive set.

Colored pencils

Colored pencils are versatile, easy to use, inexpensive, and portable—perfect for both studio work and outdoor sketching. They come in a wide range of colors, either singly or in selection boxes, and can create anything from delicate linear drawings to loose, open sketches. Like graphite pencils, tones vary according to the pressure used. Colors can be mixed by blending. Water-soluble pencils combine the precision of pencils with the painterly effects of watercolor to create background washes and lovely, soft line work. For colored pencil work use good-quality smooth sketching or hot-pressed watercolor paper, or try out the effects of slightly textured pastel and cold-pressed papers.

Wax crayons

The chunky wax sticks of childhood have matured into a vibrant range of intensely pigmented artists' crayons—including metallics, for a touch of fairy shimmer. They cover well to produce swathes of intense color and expressive linear marks, and they can be used for textural wax-resist effects. Normally the color can only be moistened with white spirit, but a new generation of wax pastels is water-soluble and can be used on wet or dry paper for a host of exciting line, wash, impasto, sgraffito, and mixed-media techniques. Smooth sketching or hot-pressed papers create successful wax crayon images, or for more textured effects and wax-resist techniques try cold-pressed and rough papers.

Soft pastels and pastel pencils

Pastels create delicate, misty dustings of subtle color, or emphatic sweeps of vibrant tones. They mix and blend easily on the page to create hosts of varied tones and produce expressive, broad line-work. With pastels, less is more, and a light touch is vital—overwork them and they quickly become dull and muddy. Soft pastel sticks are round and protected by a paper casing, while harder sticks are usually square. Pastel pencils are slightly harder than sticks but retain the same blending qualities while allowing finer linear detail, and are much cleaner to use. All pastels require a paper with some "tooth," or surface texture to hold onto the pigment particles.

Specially-made pastel papers come in neutral white and creams, and in a wide range of colors that can enhance the effects of the medium. A fixative spray is useful to protect the work from smudging.

Inks

There is a wide choice of colored inks available for both linear pen work and broader brush techniques. Some are water-soluble, while acrylic inks are permanent when dry so they can be combined with watercolor paints. Both are wonderfully vibrant in color, and both can be diluted with water for softer washes and airbrush techniques. Used sparingly, pearlescent inks are perfect for adding ethereal touches to fairy environments. For line drawing, sepia ink is popular for fairy subjects as it is less harsh than black. For pen work use smooth papers that won't impede the line or clog the nib; for calligraphic brush work and wash effects choose hot or cold-pressed watercolor papers.

Colored fiber tips and markers

Once upon a time, fiber-tipped pens were mostly black and intended for writing. Now there's a huge variety of modern pens and markers in a large array of colors and have their own unique qualities for artists. For fairy pictures they need to be handled carefully, or the results can be harsh and unsubtle. Nevertheless, the variety of tips and wide range of colors offer interesting possibilities. The addition of water-soluble pens allows subtle and softer effects to be created. Fiber-tipped pens need smooth drawing papers that will accept the ink without allowing it to bleed and spread. A good-quality sketching or hot-pressed watercolor paper is perfect.

Water-soluble pencils

All colored pencils come in a range of fabulous colors with subtle hue/color changes. The pencils here are water-soluble, giving even more control over the color or tone.

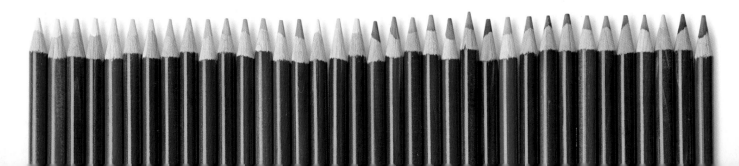

Bold marks
Markers come in a wide range of tip sizes. Keep a range of sizes on hand to make varied marks and create more interest in your drawings.

The wonderful world of markers
Markers today are incredibly versatile and range from very thin to very thick.

A medium- to thin-width fiber-tip pen makes wonderful black lines for details and outlines.

Mix media: use an ink wash over your marker pens for an interesting new look.

Lay your marker colors boldly down on the page.

Use a blending pen (which contains a solvent) to mix the thick marker's somewhat harsh marks for a softer effect.

Using other media in fairyland

Waxy colored pencils

Waxy color doesn't spread easily, so create a blend with two colors, working one over the other to make a shaded area (the overlap creates a pretty third color, too).

Chalky colored pencils

Chalky pencil colors can be easily blended by rubbing. Work one color over the other with loose strokes, then blend the two with your fingertip or a cotton swab.

Oil pastels

Use the "scumbling" technique to create soft blends: one or more colors are applied over each other in light veils, so that each color partially covers the one below.

Pen and brush tone

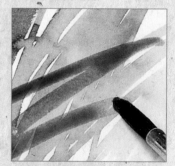

Water-soluble pen inks can produce a wide range of tones according to the amount of water with which you dilute them. Use a paint brush to apply the water.

Brush and ink

Colored ink can be used directly from an ink pot (see right) and applied with a brush like paint. An oriental brush is used, above.

Wax crayon resist

Draw simple lines or shapes with wax crayon, then paint over with thick, opaque gouache (as shown above) or any kind of paint.

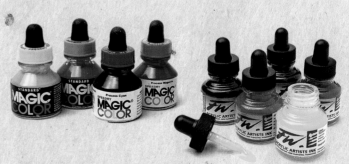

Colored inks
Colored inks are used in the same way that you use black ink (see page 11).

Transferring an image

When you want to copy an image you'll need to reproduce it as close to the original as possible. There are plenty of images in this book for you to copy, or you might want to work from drawings in your sketchbook or photographs that you have taken of perfect fairy habitats. There are two methods for transferring accurate copies ready for painting: tracing and using a grid. Simple tracing techniques reproduce the image at the same size as the original. With a grid, however, you can create a same-size copy, or you can enlarge or reduce it while still producing an accurate copy.

You will need
- Good quality tracing paper
- Ready-coated graphite paper. If you can't find this, make your own. Take a piece of copier paper and rub an HB graphite stick all over one side so it is coated with powder. Re-coat it after each use for clear copies.
- Masking paper
- HB and 4H pencils
- Low-tack masking tape
- Drawing paper

Tracing images

Tracing is a simple way to produce accurate, same-size copies of your chosen images. You just place the tracing paper over the image you want to trace, secure it in place with small pieces of masking tape, and use an HB pencil to draw the main elements of the subject onto the tracing paper. Then you can transfer the tracing to your paper in one of the following ways.

Making an exact copy with graphite paper

This is a nice, easy method of transferring your traced images onto paper. It will create an almost exact copy of the image you wish to reproduce, though in order to achieve the best results remember to draw over your lines as accurately as possible, and keep an eye on the drawing as you progress, just to make sure that you have all the lines traced out.

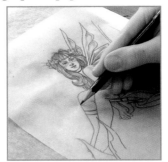

Secure the image. Place the graphite sheet under the tracing paper and, with a sharp 4H pencil, draw over the original. If the graphite messes up the paper beneath, erase any fogging when the tracing is complete.

Remember to lift the sheets to check your work every so often as you progress. If the image is very faint, it might help to go over some of the lines while you still have the paper secured.

Here you can see how the image appears on your drawing board. The copy should be almost the same as the original. When you are happy with your image, carefully remove the tracing sheet and graphite paper.

Making a mirror image with masking paper

As long as you remember to check your work as you progress, and always try to draw over the existing lines very carefully, this is a simple, effective method. Once you have traced your desired image onto your tracing paper with an HB pencil, you can begin to transfer it to your paper. There is no need to use graphite paper in this instance.

Make sure that the tracing sheet is placed drawing-side down (i.e. the HB pencil lines are facing the paper surface). The image will appear reversed. After making sure that it is secured, use a 4H pencil to draw carefully over the image.

Check the image often to ensure that you are transferring all of the image to the paper. If you find the image too faint, go over the lines again while your tracing sheet is in place. It is difficult to re-align an image after you have finished.

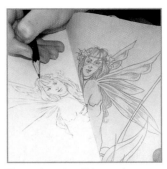

The end result will be a mirror image of the traced image. Remove the tracing paper very carefully and go over the image with your HB pencil (or a pen, if you prefer).

Using a grid

A grid is a handy way to reproduce images that you want to enlarge or reduce. Of course you can also use it to create same-size copies.

1 Onto an acetate sheet, using the ruler and fine-line pen, draw a grid of one-inch (2.5 cm) squares large enough to cover the picture you want to reproduce.

2 Secure the picture to a piece of paper or cardboard with small pieces of masking tape. Lay the acetate grid over it and secure that in place, too.

3 On your drawing paper, use your HB pencil really lightly to draw a faint grid with the same number of squares. For a same-size copy use the same size squares. To enlarge the image use bigger squares, and to reduce it use smaller squares.

4 Now copy the information in each square, one square at a time. Concentrate and work slowly and you will end up with an accurate facsimile of the original. As long as your grid lines are very faint they will be covered by your paint. Any that remain outside the picture area can be erased carefully when the painting is complete.

Photograph with an acetate grid

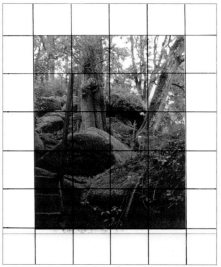

Pencil sketch extrapolated from the gridded photograph

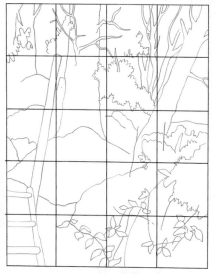

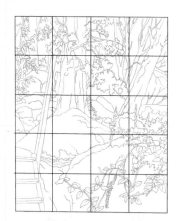

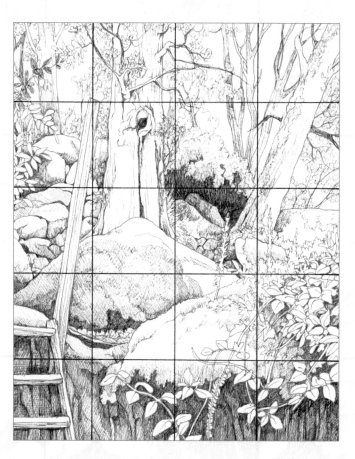

Using the grid method, you can draw as much detail (right) or as little (above) as you like.

You will need

- Sheet of clear acetate large enough to cover the image and overlap a little on each of the sides
- One black, permanent, fine-line pen
- A ruler
- An HB pencil
- Drawing paper
- Spare sheet of paper
- Low-tack masking tape

How colors work

For your paintings of fairyland to be successful and have the impact you want, you need to be able to convey the right mood and atmosphere. Achieving this is largely a matter of understanding colors and how they work. So before you begin to paint, it's important to learn about basic color relationships, how to mix colors, and the visual effects they create when you combine them in a painting. With experience, practice, and a few simple guidelines, you'll learn to create a wide range of shades and colors from a basic palette, and to use them effectively. Your sketchbook is a good place to record your experimental color mixes for future reference.

Primary and secondary colors

Red, blue, and yellow are the three primary colors, so called because they cannot be mixed from other colors. Mixing two of these primary colors together produces a secondary color, orange (red and yellow), green (yellow and blue), or purple (blue and red). A simple color wheel explains these colors. Experiment with these simple secondary mixes by changing the proportions of each color mix—for example, a lot of red and a little yellow will make a deep orange, while a lot of yellow and a little red will make a bright citrus orange.

Color wheel

1. Primary: such as alizarin crimson, cadmium red, permanent rose
2. Secondary: orange, made from a mix of red and yellow
3. Primary: such as lemon yellow, gamboge, or cadmium lemon
4. Secondary: green, made from a mix of yellow and blue
5. Primary: such as cobalt, phthalo, or ultramarine
6. Secondary: violet, made from a mix of blue and red

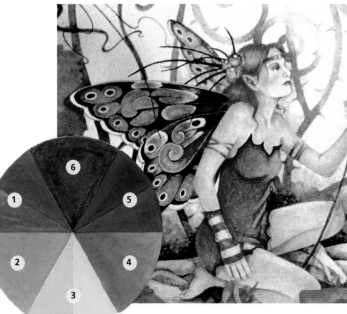

Primary detail
The main color focus in this detail from the painting (top right) is the primary blue of the fairy's wings and dress.

Tertiary colors

If you mix a primary color with a secondary color you'll produce a tertiary color. Mixing colors that are next to each other on the color wheel produces harmonious and often vibrant blends, while mixing colors that are opposite each other produces more neutral and muted shades. Experiment to see the possibilities.

Color wheel
1. Red
2. Red-orange
3. Orange
4. Yellow-orange
5. Yellow
6. Yellow-green
7. Green
8. Blue-green
9. Blue
10. Blue-violet
11. Violet
12. Red-violet

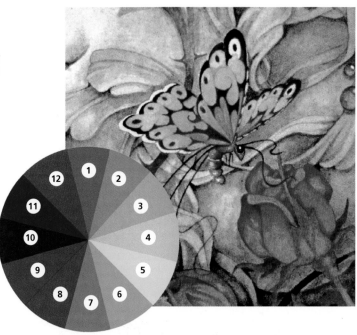

Tertiary detail
The vibrant color details in the painting come from tertiary colors like the red-orange on the rose, and the yellow-orange on the butterfly's wings.

Harmonious and complementary colors

Look again at the color wheel diagram. Notice that colors that are next to each other create a quiet relationship—look at the partnership of green and blue, for example. These are called "harmonious colors." On the other hand, colors that are opposite each other on the color wheel create vibrant effects—think of red berries among green foliage. These opposites are called "complementary" colors, because each enhances the other. Complementary contrasts help to draw the eye around a painting and create visual excitement—in a leafy scene, small spots of echoed red or red-brown brighten the greens and carry the eye from place to place.

Complementary

Blue and orange opposites on the color wheel create striking effects with orange roses, a blue fairy, and a mellow green backdrop.

Color temperatures

Colors can be described as "warm" or "cool," and this plays an important part in painting. Warm or hot colors are vibrant and loud; cool and cold colors are gentler and more restful. In a landscape, colors get paler and bluer with distance, while the foreground is warmer and brighter. Look again at the color wheel and you'll find it can be divided in half. On one side are the warm reds, yellows, and oranges, and on the other are the cool blues, greens, and purples. However, there are several shades of each primary color. For example, there are reds that lean toward warm orange and reds that lean toward cool blue. To create a large array of colors you need the following warm and cool versions of each primary:

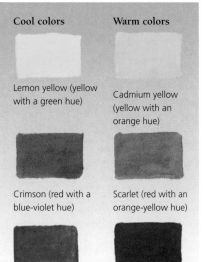

Cool colors

Lemon yellow (yellow with a green hue)

Crimson (red with a blue-violet hue)

Cerulean (blue with a green hue)

Warm colors

Cadmium yellow (yellow with an orange hue)

Scarlet (red with an orange-yellow hue)

Ultramarine (blue with a violet hue)

Primary color mixes

To achieve the colors you want, keep in mind the tonal leanings of your primaries. For a really intense orange, mix together the warm shades of red and yellow that have orange undertones —cadmium yellow and scarlet. For a lighter shade of orange, mix together lemon yellow with a cool green undertone and crimson with a cool blue hue. Try these mixes and the other examples shown below.

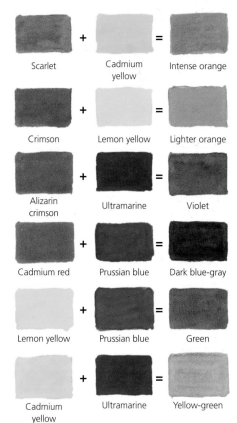

Scarlet + Cadmium yellow = Intense orange

Crimson + Lemon yellow = Lighter orange

Alizarin crimson + Ultramarine = Violet

Cadmium red + Prussian blue = Dark blue-gray

Lemon yellow + Prussian blue = Green

Cadmium yellow + Ultramarine = Yellow-green

A starter palette

This palette includes warm and cool versions of the three primaries. It also includes some ready-mixed staples that you'll find useful for fairy landscapes and homes— yellow ocher, raw sienna, and burnt umber are great for fall and woodland scenes, while olive and Hooker's green provides a good basis for creating the host of different greens you'll find in nature. It also includes a black and a white—use these sparingly to create yet more shades and for adding details.

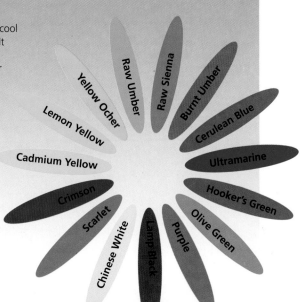

Yellow Ocher
Raw Umber
Raw Sienna
Burnt Umber
Lemon Yellow
Cerulean Blue
Cadmium Yellow
Ultramarine
Crimson
Hooker's Green
Scarlet
Olive Green
Chinese White
Lamp Black
Purple

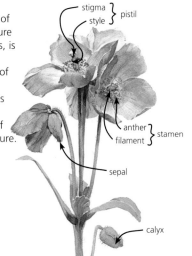

Painting flowers and foliage

Because fairies and flowers belong together, you'll want to include plenty of floral studies in your paintings. Of course, you'll also want to exercise your imagination to create exotic, magical fairylandish blooms and foliage for your scenes. You'd be hard pressed, however, to beat nature at her own game. There are literally thousands of breathtakingly beautiful wild and cultivated flowers in a stunning array of colors to inspire you. Work from life, take your own photographs for reference, or look at the many books with wonderful photographs of every species to help you choose your flowers, leaves, and a suitable palette with which to depict them. And look to nature for inspiring color combinations. Bright red poppies in a yellow cornfield or a green hedgerow make a vibrant impact, while white daisies in a green field or bluebells under spring trees provide quieter color combinations.

Learning to look at flowers

Every flower petal is different, once you look at them carefully. The structure of flower heads can be divided into various geometric shapes to help you draw them more easily. Learn to look, analyze structure, and see the flower in its entirety.

Structure of a flower

Try painting from the side, as there is a strong profile shape of stamens and petals.

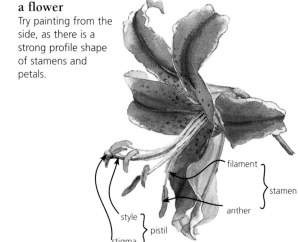

filament
stamen
anther
style
pistil
stigma

Trumpet
The inside will appear dark with the protruding stamens reaching up to catch the light.

Bell
When seen from the side, petal edges will appear light against the dark of the inside of the bell.

Pompom
Think of pompom-shaped flowers as geometrical globes and add all the details later.

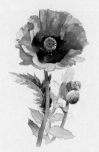

Bowl
Visualize the circle of the upper edge of bowl-shaped flowers. Seen side-on, they seem to form an ellipse.

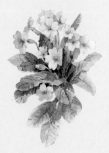

Star
Look carefully to capture the variation in size and outline of each of the individual petals.

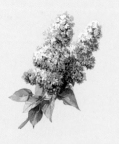

Spike
Look at the pattern of light and shade on the shape of these cylinders.

Careful study

Unlike the profile of the lily, the structure of the meconopsis, is not so obvious. Sketch a number of different-sized flowers and angles of heads to familiarize yourself with flower structure.

stigma
style
pistil
anther
filament
stamen
sepal
calyx

Mixing leaf greens

Foliage is often perceived to be just green. However, there is a truly astonishing range of greens in nature, from the palest yellow-green to the darkest glossy olive. Indeed some are so intense that they seem almost unreal; they change according to the light. Observe the variety for yourself when you are out and about. Remember, too, that leaves change color with the seasons, turning from delicate spring green to strong emerald in summer and on into a breathtaking spectrum of yellows, browns, and reds in the fall.

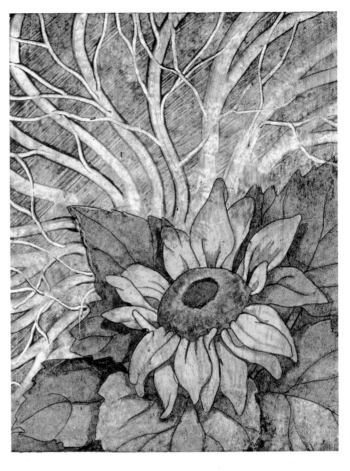

Yellow-green
Lemon yellow highlights, glazed over with sap green for the mid-green, with indigo added for shadows.

Blue-green
Lemon yellow highlights with a touch of cobalt green, glazed over with cobalt green for the mid-green, with indigo added for shadows.

Red-green
Naples yellow highlights, glazed over with phthalo green for the mid-green, with burnt sienna added for shadows.

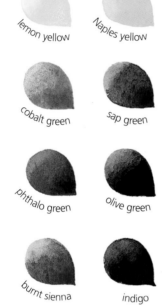

lemon yellow

Naples yellow

cobalt green

sap green

phthalo green

olive green

burnt sienna

indigo

The traditional sunflower
By being surrounded by slightly surreal, bent trees, the sunflower is transferred to fairyland. This blossom is painted directly from nature (could have been pulled directly from your sketchbook!) but it is transformed by its dizzying backdrop into something appropriate for a fairy scene.

Nature's colors
Certain color combinations immediately suggest specific varieties of flowers. Just the right shades of yellow and green, for example, conjure up the image of a field of daffodils in springtime.

Poppies
Use cadmium red and alizarin crimson, with Payne's gray and purple madder for the center.

Violets
Make a mix of ultramarine, purple, and lilac for violets, anemones, and bluebells.

Buttercups
Buttercups and daffodils take cadmium yellow, lemon yellow, and a hint of orange.

Forget-me-nots
Soft washes of cobalt blue and ultramarine, with darker mixes at the flower's center.

Fairyland weather

The weather affects the sky, the sky affects the light, and the light affects the landscape and all the elements in it. So the weather condition is obviously a vital element to consider when you plan a fairy landscape painting—it will determine the colors you use and the way that you apply them. Of course it's not always benign and sunny in fairyland. Sometimes you'll want to create a more enigmatic atmosphere with rolling mists or brooding skies. It's important, therefore, to know what colors will help you achieve the right effects while still retaining an ethereal and mysterious fairyland quality.

A palette for all weathers

This small nine-color palette will give you plenty of options for depicting a variety of weather conditions and skies. Some can be used alone in dilute washes: however, mixing them together in various combinations will create much more convincing effects, particularly if you want to create misty scenes and ominous skies. All the following examples of weather effects have been produced using this palette.

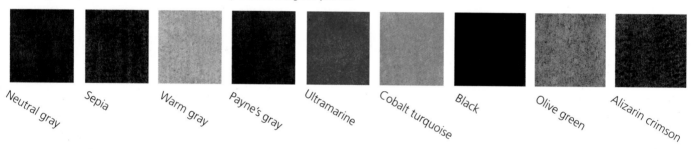

Neutral gray Sepia Warm gray Payne's gray Ultramarine Cobalt turquoise Black Olive green Alizarin crimson

Sky effects

Cloudless summer sky
Create a celestial blue sky with random wet-in-wet washes of cobalt turquoise and ultramarine blue. Use horizontal brushstrokes and allow the washes to bleed into each other for an almost tropical blue summer canopy.

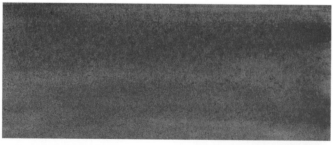

◀ Use this type of fairyland sky for unblemished summer days with not a cloud in sight. Review types of fair-weather clouds (cumulo-nimbus is a big, fluffy white one) on the Internet to create a variation on this cloudless sky.

Threatening sky
Just two colors are used again, this time to create the effect of a brewing storm. Apply washes of ink black and alizarin crimson with horizontal strokes to opposite corners of the painting, allowing them to bleed together wet-in-wet in the center. Tissue out some wet paint to create the thunderclouds.

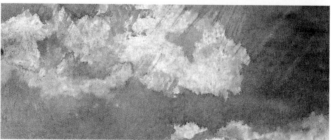

◀ Let the weather you choose dictate the mood of your fairyland painting. Perhaps an ominous sky like this with imminent rain would be best over a scene of distress. (Use your imagination. Has something gone wrong in fairyland?)

Sunlight through clouds
Light beams can break dramatically from behind clouds in any direction, not just downward, and are not opaque. Allow some structures behind the light beam to show through so the light doesn't look solid.

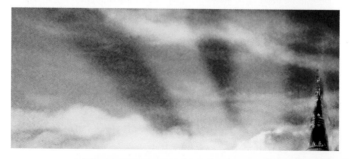

◀ Small horizontal clouds viewed against the brightness behind them will often appear quite dark, and can be a very effective way to set off the sunlight and make it appear brighter.

Snow-laden sky

This leaden sky heralds snow. Apply horizontal washes of Payne's gray over most of the sky, blending in an alizarin crimson wash at the bottom for a bleak, wintry look. Use a damp brush to lift out thin whispers of cloud.

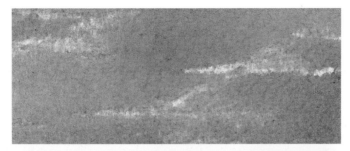

◀ What would a fairyland under this sky look like? Maybe all the fairies are rushing around trying to get their provisions stored for winter; perhaps one rebellious young fairy is lounging around, refusing to do any work and being scolded by passersby.

Rain

From a distance, rainfall looks like a series of "curtains," soft-edged and indistinct. Rain seldom falls straight down. It is often pushed slightly by the wind into the familiar arching shape.

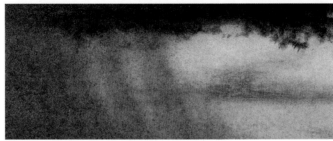

◀ Allow some background sky or cloud to show through the leading edge to give the sheets of rain a sense of transparency.

Misty scenes

Misty mountains

Just two colors create this evocative scene. Apply a dilute sepia wash at the top of the page, and blend it with a Payne's gray wash on the lower half of the page. While the paint is still wet, use some tissue to lift out a little color where the two washes blend. When the paint is dry, use a stronger sepia wash to add the mountaintop emerging from the mist.

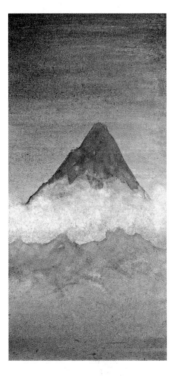

◀ This is the mysterious, dormant volcano, everpresent in the background of fairyland. Only once before has it blown its top. Might it be due for another explosion? What would happen to fairyland?

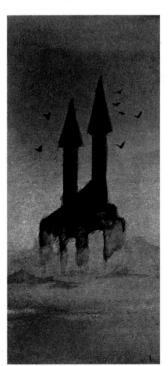

Low-lying fog

Here the castle emerges from a low carpet of fog. Working wet-in-wet with horizontal brushstrokes, apply a Payne's gray wash at the top and bottom of the page with a lighter-colored warm gray wash in the center. Let the paint dry, and then add the castle silhouette with diluted black ink. Gradually fade the color so the castle seems to disappear into the fog.

◀ The government of fairyland meets in this castle to discuss the need for new rules and regulations to keep order in the land. The castle is not as scary as it looks!

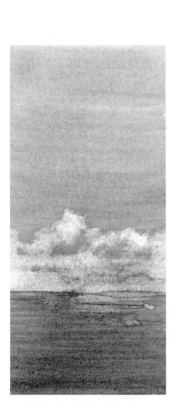

◀ The sea mist is a very important part of the habitat of water fairies because it helps to camouflage their movements from prying human eyes.

Rolling sea mist

To create this atmospheric effect divide the page in half and use horizontal brushstrokes to apply a thin wash of warm gray at the top. Then apply an olive green wash at the bottom so it merges wet-in-wet at the invisible horizon line. While the paint is still wet, lift out some color with a scrunched-up tissue to suggest the rolling mist. Notice how horizontal brushstrokes help to indicate water in the foreground.

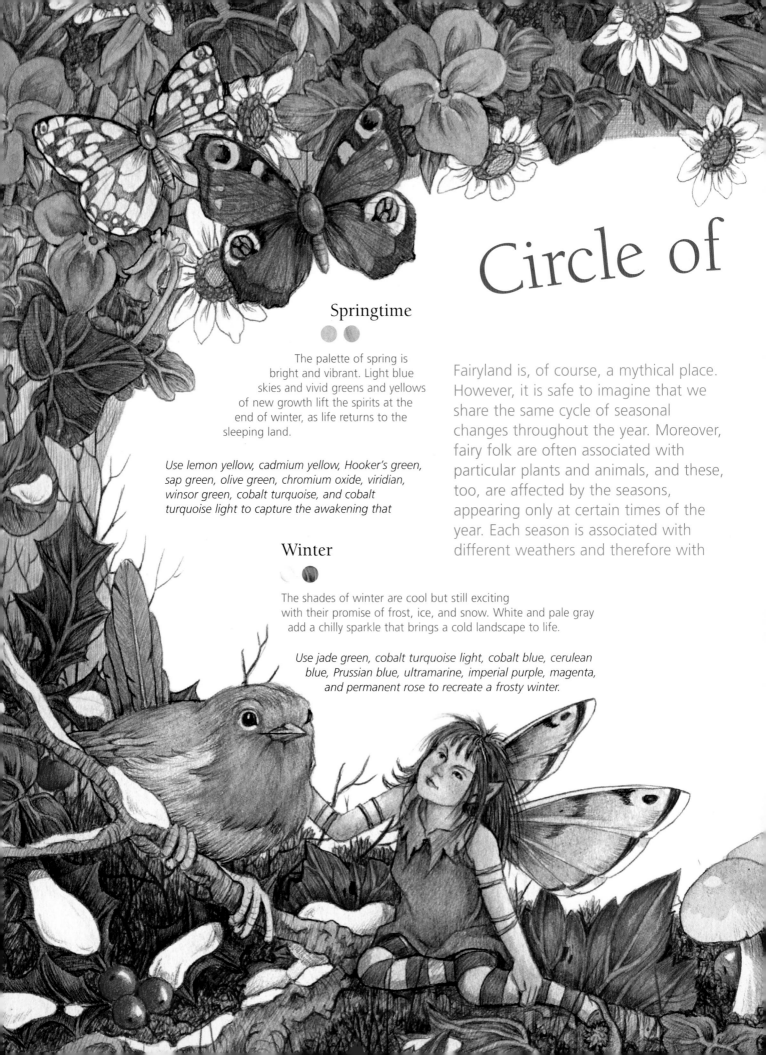

Circle of

Springtime

The palette of spring is bright and vibrant. Light blue skies and vivid greens and yellows of new growth lift the spirits at the end of winter, as life returns to the sleeping land.

Use lemon yellow, cadmium yellow, Hooker's green, sap green, olive green, chromium oxide, viridian, winsor green, cobalt turquoise, and cobalt turquoise light to capture the awakening that

Fairyland is, of course, a mythical place. However, it is safe to imagine that we share the same cycle of seasonal changes throughout the year. Moreover, fairy folk are often associated with particular plants and animals, and these, too, are affected by the seasons, appearing only at certain times of the year. Each season is associated with different weathers and therefore with

Winter

The shades of winter are cool but still exciting with their promise of frost, ice, and snow. White and pale gray add a chilly sparkle that brings a cold landscape to life.

Use jade green, cobalt turquoise light, cobalt blue, cerulean blue, Prussian blue, ultramarine, imperial purple, magenta, and permanent rose to recreate a frosty winter.

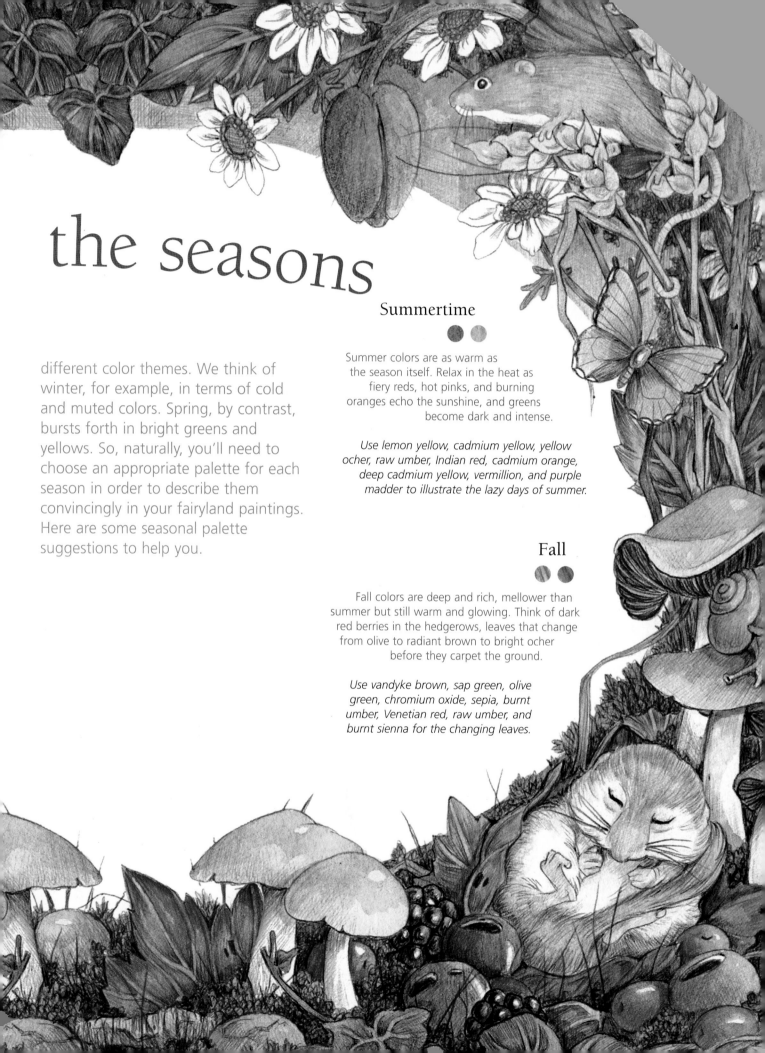

the seasons

different color themes. We think of winter, for example, in terms of cold and muted colors. Spring, by contrast, bursts forth in bright greens and yellows. So, naturally, you'll need to choose an appropriate palette for each season in order to describe them convincingly in your fairyland paintings. Here are some seasonal palette suggestions to help you.

Summertime

Summer colors are as warm as the season itself. Relax in the heat as fiery reds, hot pinks, and burning oranges echo the sunshine, and greens become dark and intense.

Use lemon yellow, cadmium yellow, yellow ocher, raw umber, Indian red, cadmium orange, deep cadmium yellow, vermillion, and purple madder to illustrate the lazy days of summer.

Fall

Fall colors are deep and rich, mellower than summer but still warm and glowing. Think of dark red berries in the hedgerows, leaves that change from olive to radiant brown to bright ocher before they carpet the ground.

Use vandyke brown, sap green, olive green, chromium oxide, sepia, burnt umber, Venetian red, raw umber, and burnt sienna for the changing leaves.

Using color to create mood

Fairies are colorful, emotional creatures—sometimes even downright moody! Choosing the correct colors for your fairy paintings is the first step toward effectively capturing all the magical castles, mysterious forests, and cute-as-a-button fairy homes in their enchanted world.

Trace this

Use this simple line drawing as a base to create a variety of moods. Trace the image or draw your own pencil outline.

You will need

- Watercolor paper
- HB pencil
- Selection of watercolors
- Wash brush
- No. 6 and No. 2 brushes

Welcome home

Castles are traditionally intimidating, so achieving a friendly feeling is a feat in itself.

Use a wash of chromium oxide over the image and a darker olive green for the castle itself (applied in a thin wash). Choose a heavier mix for the details and chromium oxide mixed with olive for the foreground. Use viridian hue, a hint of neutral gray, and chromium oxide for the background washes.

Palette
- Chromium oxide
- Dark olive green
- Viridian hue
- Neutral gray

Travelers beware!

Who would you expect to find lurking inside this castle? Think twice before knocking on this door in a foggy twilight.

Washes of olive green create a subtle impression of a castle in the distance. Apply a wash of olive green over the whole image, then add more subtle washes to lift it out. Be careful not to overdo it. Try using other single colors to create the same effect.

Palette
- Olive green

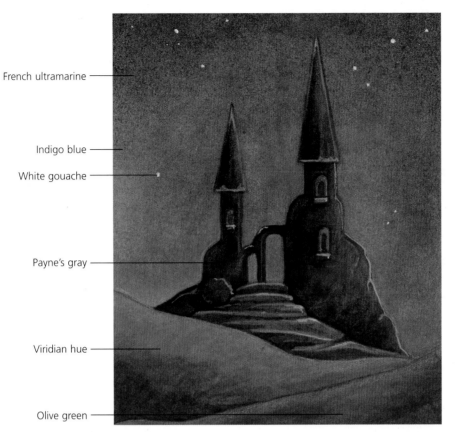

French ultramarine

Indigo blue

White gouache

Payne's gray

Viridian hue

Olive green

Castle at midnight

Paint an indigo wash over the entire image. When dry, add a hint of French ultramarine to the top edges of the sky, making it look much darker. Fill in the castle with Payne's gray, and the foreground with viridian hue and olive green.

Once dry, add washes of white gouache to the scene. Add moonlit highlights to the right-hand side of the castle and across the top surfaces of the foreground.

A nighttime sky is always much darker at the top and lighter at its horizon line, so add a wash of white gouache to the horizon and around parts of the castle. Finish off with some spots of gouache for stars.

Disappearing castle

In fairyland it's not unheard of for entire castles to suddenly vanish one day and reappear the next!

Paint an even wash of indigo over the whole image. Once dry, add washes of white gouache over the edges and blend toward the castle's center and foreground.

Add heavier washes of gouache to the edges, and highlights to the steps and foreground. Add cloudy effects using gouache.

Palette
• Indigo blue
• White gouache

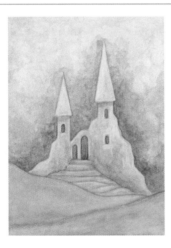

Ice palace

You might think that lands of ice and snow aren't traditional fairy habitats—think again.

Use a background wash of cobalt blue, then add more washes around the castle to create a billowy cloud effect.

Paint the snowy castle and foreground with a lighter wash of gray. When it has dried, add some washes of white to lighten the castle and make the foreground look slightly darker.

Palette
• Cobalt blue
• Neutral gray
• White

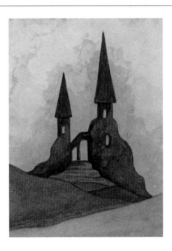

Elegant silhouette

A castle is, after all, a home for royalty. One look at this castle, backlit with morning light, and it's easy to believe that here is the home of an ancient fairy family.

Apply a background wash of viridian hue, then add more to the foreground—keep the front lighter than the background. Apply Payne's gray to the castle to make the silhouette, with a glow of green-gold washes painted around the edges.

Palette
• Viridian hue
• Payne's gray
• Green gold

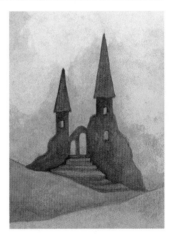

Fiery, supernatural glow

This otherworldly glow conjures up magic spells and fairy lore.

Drop in a light, all-over layer of raw umber, then washes of orange to the castle and surrounding area. Once dry, paint the castle with raw umber, applying washes to the foreground (lighter at the front and darker toward the back). Add hints of cadmium orange to the outside of the castle, orange to the foreground and steps, and a dab of permanent red for glow.

Palette
• Raw umber
• Cadmium orange
• Permanent red

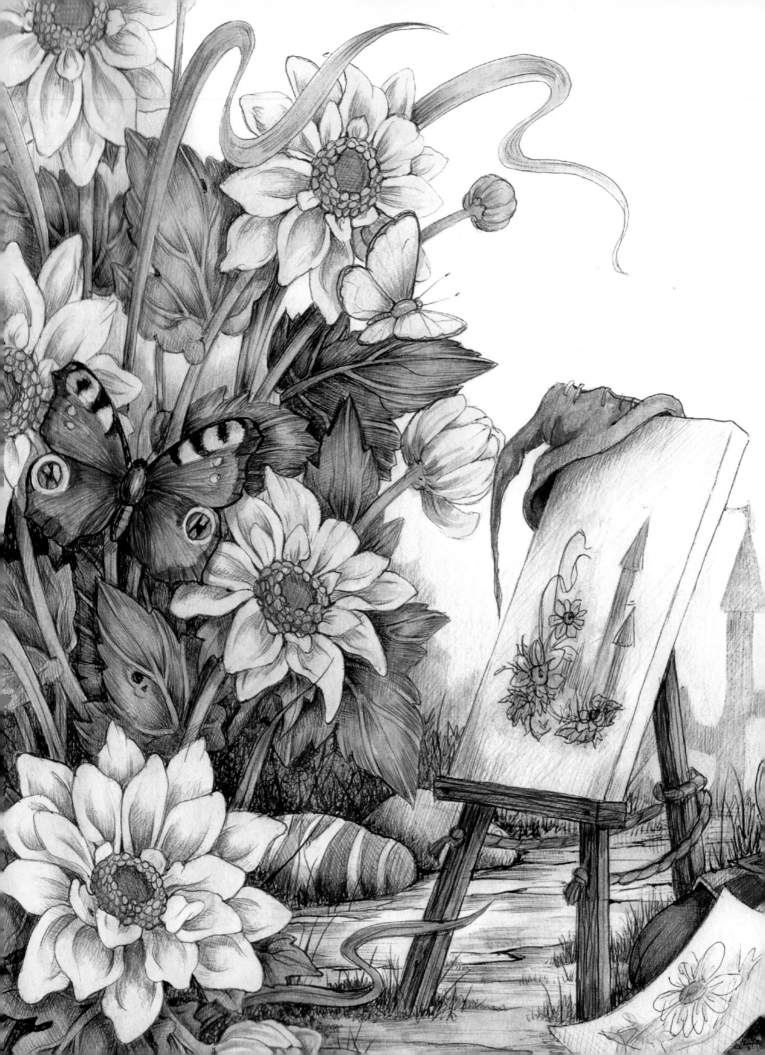

Chapter 2

Picture Making

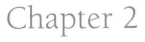

*Gathering information and inspiration for fairyland paintings is
very important. Using your imagination effectively can sometimes
be tricky, but new ideas can be found on a daily basis if you
know where and how to look at things.*

Gathering fairyland inspiration

I am fortunate enough to be able to imagine fairyland on a daily basis—my love of nature and wild imagination is enough to take me there whenever I like. In fact, my mind is so full of wonderful things, I can't wait to get them all down on paper.

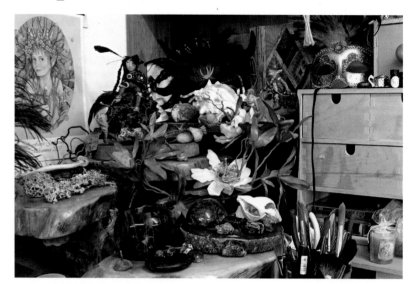

Create a beautiful, personal workspace
Cram your workspace with inspiring things. Surround yourself with the elements and materials that will inspire you to create fairyland paintings whenever you catch a glimpse of them out of the corner of your eye.

Find your own fairyland

Here are a few ideas that might help to get those creative juices flowing to inspire you onward to original thoughts and the creation of magical paintings.

Get back to nature
First and foremost, get back to Mother Nature. Try to find the time whenever you can to take a walk in the woods, by the river, or even through the local park. Anywhere that has that sense of natural peace and tranquillity—even a cultivated garden—can induce feelings of wellbeing. I tend to imagine the woodland as my fairy kingdom, though there is no reason why you couldn't find fairies living in the city or nestled among the flowers in your back yard.

Record what you see
Always take a sketchbook (see page 34) and pen or camera with you, so that you can draw or photograph any interesting plants or scenery. Collect objects such as snail- and seashells, crystals, and driftwood, as well as other interesting curiosities and found objects. I also gather colored wools, fabrics, feathers, and flowers for pressing, and I keep a selection of pretty objects on a shelf in my studio. I keep the smaller, more fragile items in a chest of drawers for reference in my paintings (when I need, for instance, to reproduce the shape of an oak leaf).

Keep a reference library
It's also a good idea to have a collection of reference and art books available to look through, or simply browse through them in your local library. Always find books that interest you personally—they are the ones you are most likely to pick up and be inspired by.

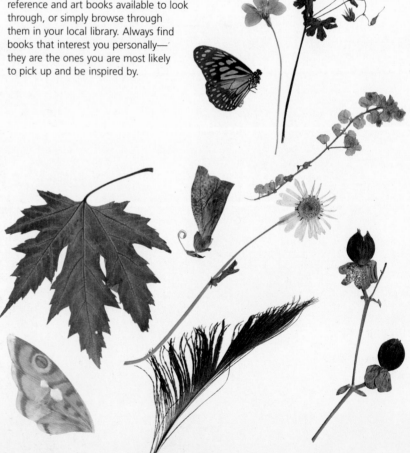

Collections
Flowers, leaves, and feathers are everywhere. You may even come across organic materials like discarded snail shells and poor dead butterflies (fairies bury them in matchboxes).

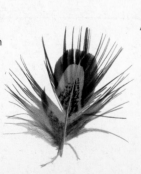

Putting your reference photos to work

The reference photos you take on your forest walks (with your sketchbook, pen, and camera, of course!) are invaluable. They remind you, once you are back in your studio, of the trees, bark, and unusual vegetation you have seen that day. But the usefulness of your reference photography doesn't have to end there. You can use them to assist you with things like scale and composition by digitally inserting your painted fairy elements into the real photographic backgrounds, and then painting from them.

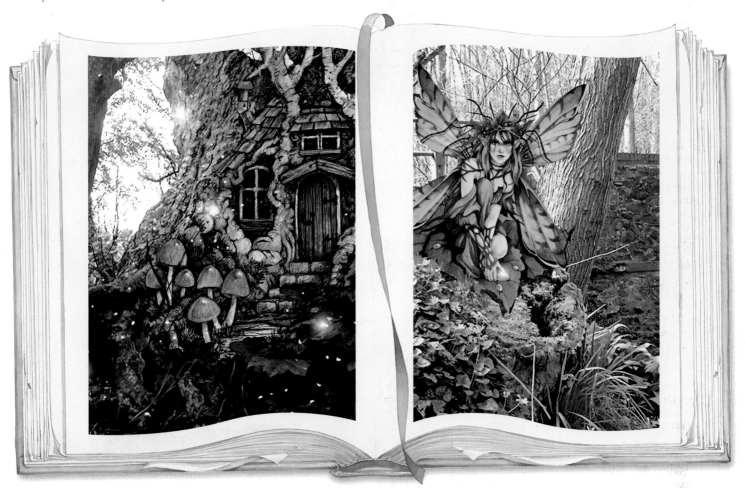

The basic elements
All kinds of reference photography can be used as a starting point for illustrations. Take pictures of natural compositions and imagine placing fairyland elements within them. Have the fairy elements you would like to try in the natural environment either scanned (if they have been created traditionally), or, if digital, saved in a convenient place.

Keeping a sketchbook

A sketchbook is an indispensable tool for the fairyland artist. Not only are you encouraged (as are all artists) to doodle and improvise at any hour of the day to further your technique and exercise your imagination, but you should also keep a record of the reference elements you see, for use (in combination with your imagination) in your studio afterwards.

Phone call sketch
Here is one of my typical phone call sketches (as you can see, anything goes!). Just doodle away spontaneously, following your imagination. I used an HB pencil here so it's a little light in color.

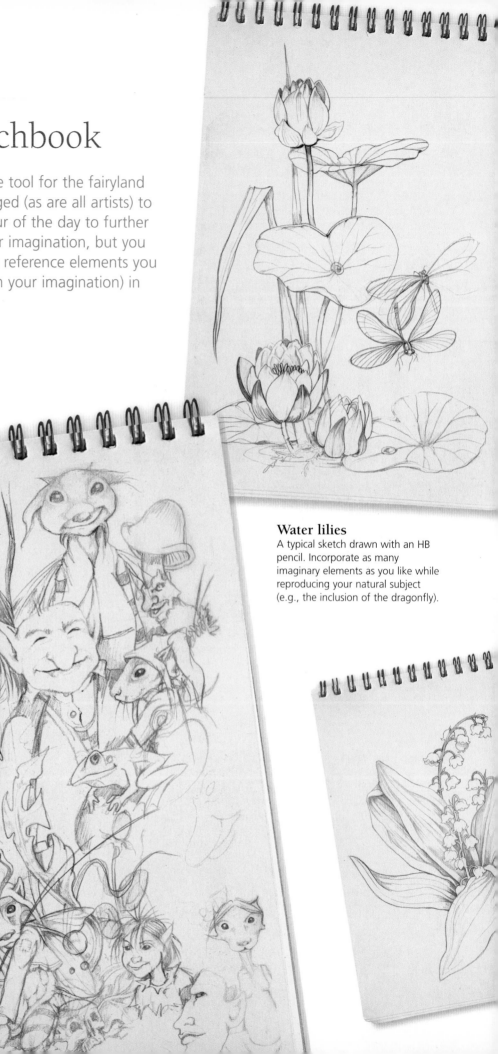

Water lilies
A typical sketch drawn with an HB pencil. Incorporate as many imaginary elements as you like while reproducing your natural subject (e.g., the inclusion of the dragonfly).

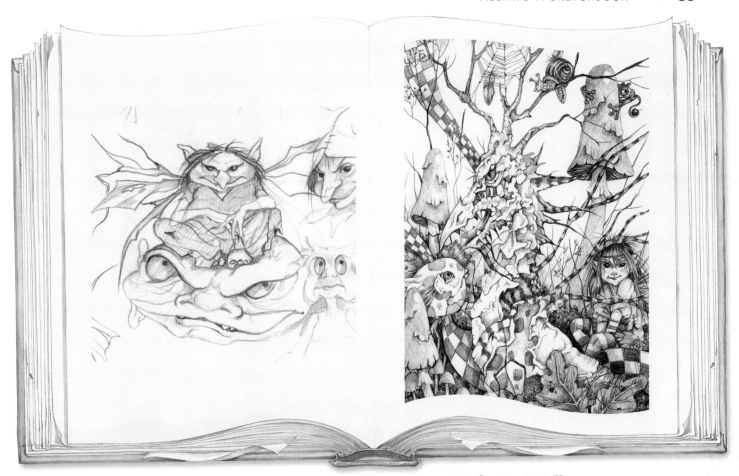

Goblin sketch

This goblin sketch was used in a painting of mine called *Bogwood*. When I looked at them in my sketchbook, they just looked like little bog creatures, all squished up!

Lily of the Valley

A HB pencil sketch from a scouting expedition into the woods. Discover and explore the natural shape of leaves and their characteristics, as well as the flower's growth pattern.

Fairyland sketches

There is no need to worry about how neat and tidy your drawings are in a sketchbook, nor how big they are (even tiny sketches can help you to create huge masterpieces). Here are two of my small thumbnail sketches, drawn when planning some of the title pages for this book (see the finished pictures on pages 30–31 and 110–111). Making these sketches helped me to decide on the overall look of the finished illustrations.

▲ To the Faerie Ball

This ballpoint pen on sketching paper doodle was made on a train journey (it's a little wobbly, due to the swaying of the train). My daughter and I were on our way to the Faerie Ball in Cornwall (United Kingdom), so I called it *To the Faerie Ball*. I always try to take a sketchbook on my travels with me. You just never know what you might be able to create.

Composition and viewpoint

Composing and designing your painting is one of the most important steps. A well-planned painting should be pleasing to the eye and will hold the viewer's attention much better than one that has been badly presented. There are some easy steps to help with composing your work, and with some practice you should be able to figure out some ideas of your own.

To help you out a little, always carry a mirror in your workbox. Whenever you are unsure about your composition, hold it up in front of your work and view the sketch through the mirror—it will give you another visual viewpoint and may help you to decide whether or not your design is going to be successful.

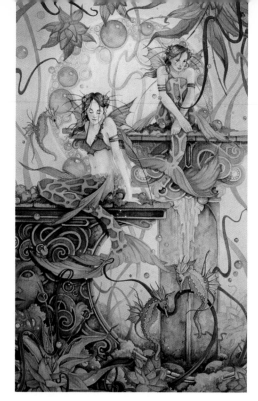

Waiting for Neptune
This image has been composed from a viewpoint that is level with the figures. Perhaps we are floating in the water directly across from them?

Composition

To compose your painting is to plan out how you are going to arrange the fairyland elements in your artwork. You might be wanting to paint a fairy in a wooded glade in a balanced composition that is pleasing to the eye. Composition is a way to communicate with your viewers, and is created through conscious decision-making by you, the artist.

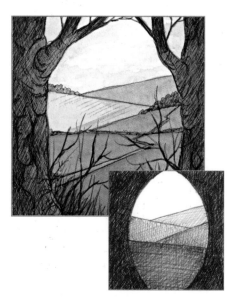

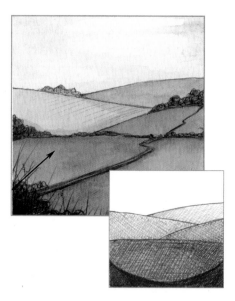

Peering out from the woodland
In this sketch, the trees are the main focus of the composition. The viewer can imagine standing behind the trees peering out to the valley below, and the composition has an air of anticipation—perhaps we are hiding from something or someone.

Open view
The same landscape, but without the trees, has a much fresher open feel—you can almost imagine standing on the top of the hill looking over the valley.

Symmetrical composition
Another effective composition is to use a symmetrical design. These simple shapes show how a symmetrical design can be arranged, and the darker areas would portray foreground interest, i.e., foliage or plants. The center shape would be the main subject matter for this piece—a castle or throne, perhaps—with the paler shapes used for the background.

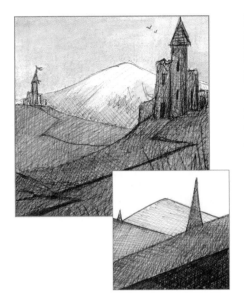

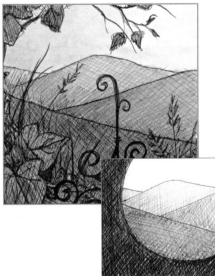

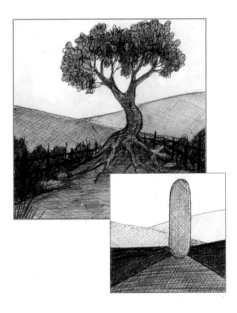

Asymmetric composition
In this scene depicting two castles, the nearest castle is the focus of attention, and feels more dominant because of its darker shading. The eye travels quickly to the second castle across the valley, and then to the distant mountain, which finishes off the composition, giving it a backdrop without having to use a horizon line.

Semicircular composition
This compositional shape is always attractive to the eye. In this sample, the ivy leaves and foliage are the focus, following a semicircular pattern around the drawing's left-hand edge. Anything of interest will be in this semicircular area, creating an intimate feel. The fields in the distance make a good backdrop.

Leading the eye in
The main subject is the tree in the middle distance. To attract the eye and lead the focus towards the tree, the hedgerows are deliberately angled inwards and painted in a darker shade than the foreground to make them distinct and eye-catching. Use this composition to focus in on a subject.

Viewpoint and perspective diorama

Get into the habit of looking at your art (even only metaphorically) from different viewpoints. This painting has been made from a worm's-eye view: the viewer feels as though they are actually beneath the painting, looking up towards the ruins from under the ground. This effect was created by using simple perspective lines (see page 42) and a horizontal floor area as a guide. Consider all points of view while you compose your piece: 1. An aerial view of the same piece of art. 2. A viewpoint from straight ahead. 3. From the left. 4. From the right. Other unusual viewpoint ideas might include peering through the surface of a swimming pool (part above and part below the waterline), or lying on the ground and looking up at the sky through the trees. These are just a few ideas for unusual creative viewpoints. Once you begin thinking like this, your imagination will come up with plenty more.

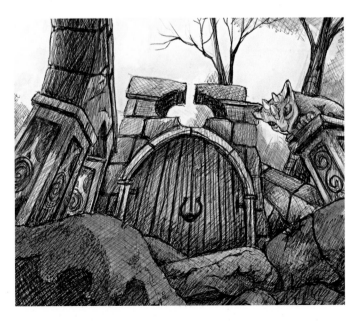

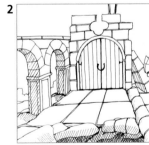

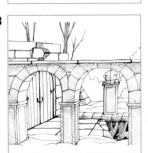

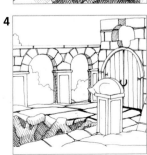

Cropping and scale

Getting a feel for your surroundings is extremely important when painting fairyland scenes—your imagination and ability to visualize what you want to portray are paramount. You can, of course, use and draw scenery and any natural settings that inspire you, but do think about how you want your painting to look, i.e., do you want to see it with a human eye or with a fairy's eye? This chapter will give you some simple hints and tips about visualizing the size and scale of your fairyland composition, so that you can make the right decisions when drawing your scene.

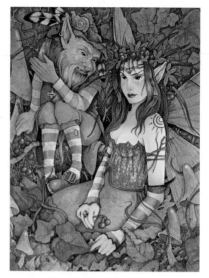

Mr. Gnome's Proposal
The close cropping onto the two central characters, ignoring the rest of the surrounding scene, illustrates the title of the piece perfectly. This is an instance where the subject matter of the work has determined the cropping.

Cropping

The technique of cropping goes hand-in-hand with composition, and directs the viewer's attention to the elements that the artist has chosen.

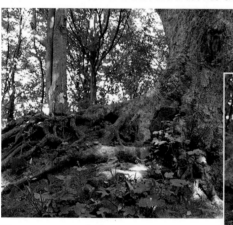

Tree roots close up
A close-up on the roots would mean we wanted to make the tree-root home the focal point of the painting, excluding the forest.

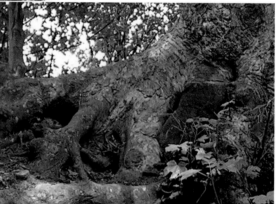

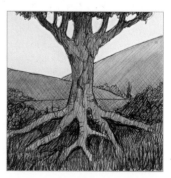

Tree roots mid-shot
Using a general mid-range shot like this is good to show a bit of the landscape surrounding your subject. If we were planning to use this photo to plan a painting of a fairy tree-root home, the forest would play a big part.

Fairy's-eye view
Cropping an image close to the ground (above) makes the viewer feel like a small fairy. Add a dimension to your images (and turn your viewer into a participant) by imposing a character on the viewer with the use of cropping.

Up close
Here is a fairy's-eye view—the door appears to be quite large in size—it feels almost big enough for the viewer to enter—and it is the main focus of the composition.

Pull back
The same tree, only this time we move further back. There is still a feeling of scale, the door feels quite big, the area beneath the tree is an intimate composition.

Door recedes
The tree is now the center of focus and the door is diminishing. There is a feeling of open space. The composition isn't as intimate as it was when we were closer.

Open-air scene
The scene is now an open-plan rural view—the tree is still the main subject though the fairy door is hardly noticeable. The attention is drawn to the scene as a whole.

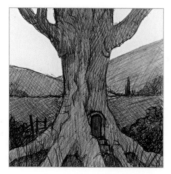

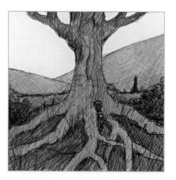

Scale

Coming to grips with scale is paramount in order to create the right atmosphere for your fairyland scenes. If your fairy characters are too large for their environment, the whole composition will fail. To demonstrate the principle of scale, I have painted a single fairy character and altered her size in each version, allowing a direct comparison with her surroundings. A leaf is an accessible reference.

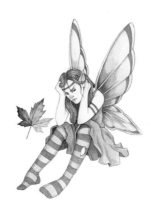

Human-sized
Because the leaf looks very small, the fairy character appears large, almost human-sized.

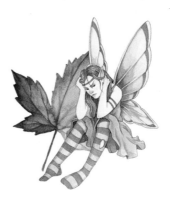

Leaf-sized
The leaf and the fairy are both the same size. This creates a very different impression of the fairy in her surroundings.

Insect-sized
This very tiny fairy is no bigger than an insect. The leaf towers over her. This scale must be adhered to for the rest of the picture.

Photographic scale
These fairy illustrations were transferred into a color photograph to show a more realistic definition of scale. The size of the photograph was unchanged; only the fairy character was altered to show how scale affects a composition. Decide how big your characters will be (some fairies are as large as humans, while others are as small as mice) and stick to it!

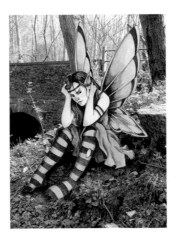

Main subject
Almost human-sized, this fairy fills the photograph and appears to be the main focus of the composition.

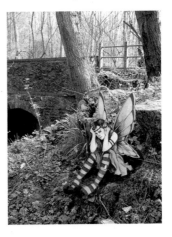

Open composition
Slightly smaller, about doll-sized, more of the surrounding scenery is visible around the character, and the composition is more open.

Background detail
A tiny fairy is now swamped by her surroundings. Even the small leaves and flowers would feel quite large to this little fairy, as she fades into the background.

Work out your scale
In this illustration you can see a pixie riding on the back of a common garden snail. Generally, large garden snails are about 1–2 inches (2.5–5 cm) in size, so we can then figure out that the pixie will be approximately 4–5 inches (10–12.5 cm) tall when standing up. If we were to paint the pixie and snail into a background, we could then figure out the approximate size of their surroundings—for example, if you were to place them among roses, a fully open rose placed next to the pixie would be about 4 inches (10 cm) in diameter, as it would be in the garden. If you were to draw the rose much smaller, you would lose the scale—the snail and pixie rider would look like giants.

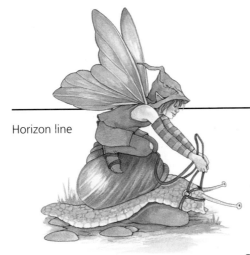

Horizon line

Relative scale
Here we can see the same pixie and snail, and although each one of them is smaller than the other, they are actually drawn to the same scale. In order to make them appear further away from each other they have been reduced in overall size, but not scale.

Ready-to-draw file:
Sacred fairy places

Finding fairyland is notoriously difficult. The most obvious place to start looking is in your backyard (if you have one), since fairies are naturally drawn to fragrant flowers and all forms of plant life. They are fond of natural beauty spots and groves of trees. They are also drawn to mysterious places and unusual things, such as sacred stones (like Stonehenge in England) or rocks carved with magical symbols. Ancient burial grounds are also very powerful fairy attractors, as are wishing wells—where fairies are attracted by the power of the wishes made there. Never step inside a "toadstool ring"—you might be suddenly transported to fairyland!

Entrances to ancient burrows and fairy burial chambers

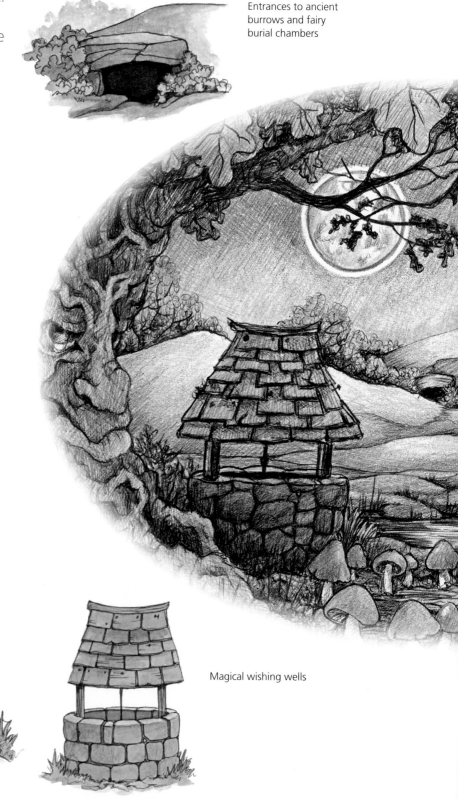

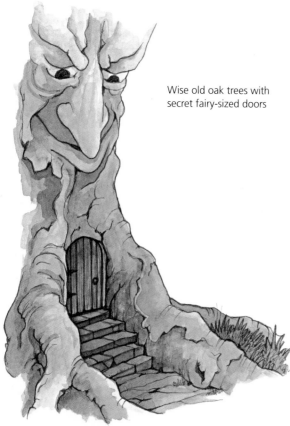

Wise old oak trees with secret fairy-sized doors

Magical wishing wells

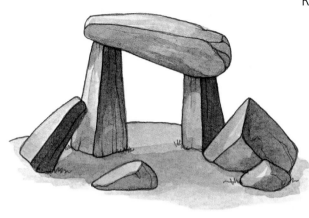

Sacred stones on moonlit nights

Magical groves deep within
the woods and forests

Toadstool "fairy" rings (caused by
fairies dancing together in a circle)

Rabbit holes (just like *Alice
in Wonderland*!)

Waterfalls that hide secret
entrances to mystical
underground mazes

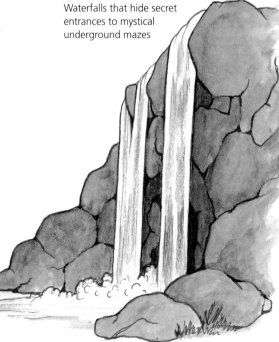

Ancient carved stones and rocks

Simple perspective

When you depict a fairy environment, you'll want to make it look as "real" as possible. This means you need to find effective ways to create a convincing sense of depth and distance on your flat piece of paper. If you can do this convincingly, your viewer will engage in a satisfying journey into and around your scene instead of skimming aimlessly across the surface. The term "perspective" refers to a set of simple devices that help you create a convincing sense of three-dimensional depth and distance in a flat image. Linear perspective and aerial perspective are two simple optical devices that enable you to create this three-dimensional illusion.

Linear perspective

There's no need to go deeply into the most complex rules of perspective. All you need to know is that when things recede into the distance they appear smaller, and that parallel lines converge towards the horizon. This can be easily observed—look at a long fence, an avenue of trees, or a row of houses. Linear perspective enables you to imitate this effect to depict convincing three-dimensional forms and scenes.

To draw anything in perspective, you first need to establish the horizon line. Even if you can't actually see the horizon, imagine a

horizontal line running across the subject at your eye level. Your eye level depends on whether you are sitting or standing, but is always straight in front of your eyes. The vanishing point is the spot on the horizon line at which the receding parallel lines appear to meet.

When you start to draw, you can sketch in the horizon line, vanishing point, and converging parallel lines lightly, or simply keep them in mind as you construct your scene.

One-point perspective

One-point perspective images draw the viewer toward the vanishing point; you can strengthen the effect by placing the subject in front of this point. Viewers focus on the area where lines converge. This effective, but limited, technique is used in paintings like Leonardo da Vinci's *The Last Supper.*

Two-point perspective

Two-point perspective is a useful method, that allows the artist to create visually effective images, and lends objects a more natural look. In this method, the sides of the object vanish to one of two vanishing points on the horizon. The object's vertical lines have no perspective applied. The illustration may look complex, but it consists simply of a large box with a smaller one on top.

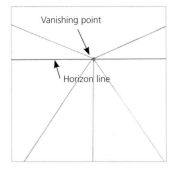

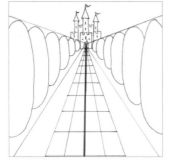

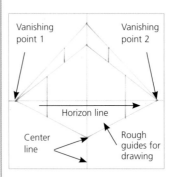

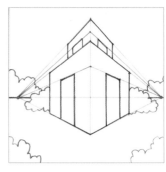

1. One-point perspective. Imagine you are standing on a set of railroad tracks. As you look toward the horizon, you notice that the tracks narrow as they stretch away from you, until they meet completely on the horizon. The point where they meet is "the single vanishing point."

2. If you move your viewpoint to the left or right side you'll see one side of the box. The parallel lines of that side will obey the rules and converge at the vanishing point straight in front of you on the horizon line. Notice that lines above the horizon slope down and that those below slope up.

1. Two-point perspective. Draw two vanishing points at opposite ends of the horizon. Use a point on the center line for the building's front corner. Add vertical lines for side walls. Use the two vanishing points to draw the wall lines, each reaching the same point on the corner.

2. Outline the shape of the building more clearly, using the framework already drawn out. Add two doors and windows. The trees and bushes require no actual perspective work, although you should make them a little smaller as they recede to keep the scale of the building.

Foreshortening

Foreshortening is actually a form of perspective, and although it is quite difficult to reproduce, it is worth practicing. It can help to give an air of dimension and proportion to your work. Foreshortening occurs when an object is viewed at an angle, causing part of the object to be seen to be further away than the front.

As you can see in the sample drawings on this page, foreshortening can significantly change the shape and look of an object; however, our brain tells us that the shape is correct and that the object is simply set at an angle. When drawing foreshortened subjects, we have to remember to abandon the usual rules of proportions and trust the laws of perspective.

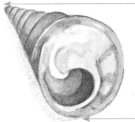

Foreshortened tree
This is a drawing of a foreshortened tree. As you can clearly see, it is being viewed from the base of the trunk. To achieve this effect, the bottom section of the trunk should be considerably larger in size compared to the top portion of the tree, which tapers off at the top.

Foreshortening guidelines
Some simple guidelines have been placed over the top of the image to help you to understand how perspective plays a part in the foreshortening of tall objects. You know the head of the tree is much wider than the trunk but your low viewpoint is making the roots look wider and the trunk is foreshortened.

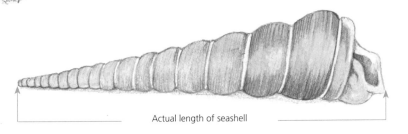

Actual length of seashell

This foreshortened view of the shell appears larger at the front and looks much shorter in length.

Seashells
Foreshortening can also apply when an object is horizontal to the eye rather than vertical. When looking at this long, conical shell in a completely horizontal, flat position we can see that it is quite a long, slender shape. However, as soon as you turn it away on an angle, its shape appears to change. The shell becomes foreshortened—its opening appears to be larger (since it is nearer to the viewer), and the longer body of the shell seems to have compacted.

Foreshortening is a type of visual distortion. Lying on your back, looking up at the sky in a forest, the tops of the trees converge and seem to crowd into the center.

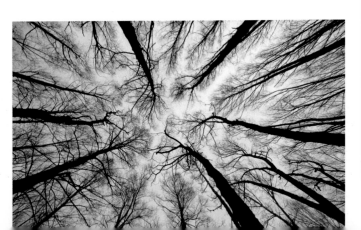

Ready-to-draw file:
Fairy friends

Fairies are at one with nature, and are likewise at ease with all animals, wild and domestic alike. Victorian master John Anster Fitzgerald painted beautiful, opulent fairy scenes, often depicting fairies and animals living in harmony. One painting in particular, *The Fledgling*, depicts a group of fairies taking care of an orphaned baby bird. It is a perfect picture of what fairy friendship is all about!

In fairyland, animal friends often help with everyday tasks. Snails, butterflies, bumblebees, and mice are all close, useful friends who help fairies gather, weave, and carry heavy objects. The wise owl is a revered oracle and is often asked for advice; rabbits and hares (often used for riding!) are great gossips and storytellers.

Bumblebees share their healthy crop of royal jelly with their special fairy friends.

Nocturnal moths are very reliable at delivering fairy love letters and important correspondence.

Songbirds use their beautiful voices to serenade at fairy weddings, and also to warn the community of danger.

Spiders are magical kin to fairies. They spin silk to be used for many different purposes, and create dream-catching webs that capture fairytales for future generations.

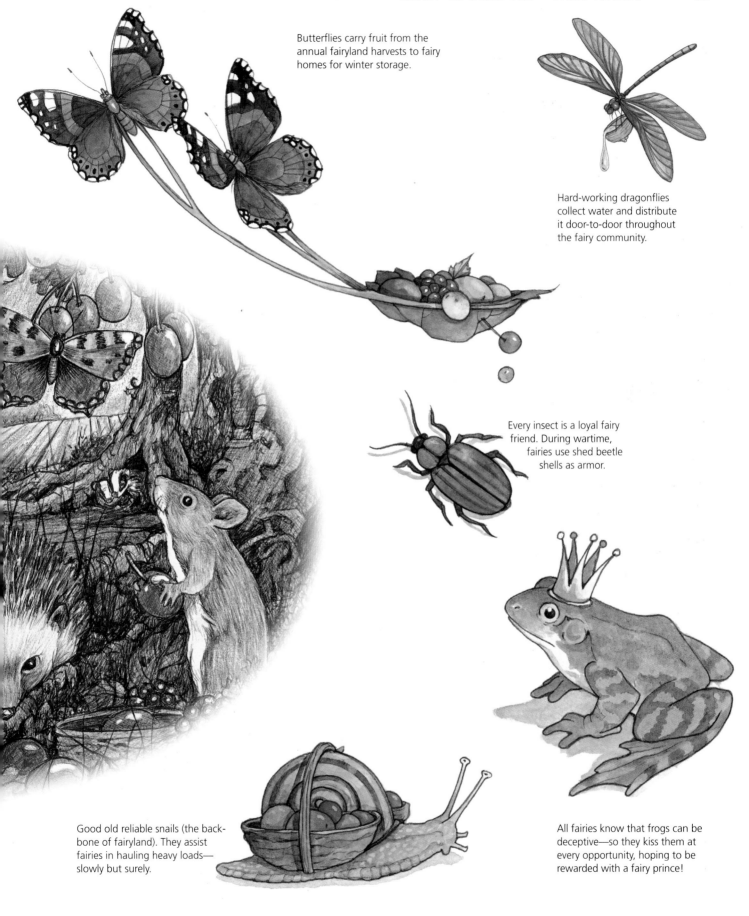

Butterflies carry fruit from the annual fairyland harvests to fairy homes for winter storage.

Hard-working dragonflies collect water and distribute it door-to-door throughout the fairy community.

Every insect is a loyal fairy friend. During wartime, fairies use shed beetle shells as armor.

Good old reliable snails (the backbone of fairyland). They assist fairies in hauling heavy loads—slowly but surely.

All fairies know that frogs can be deceptive—so they kiss them at every opportunity, hoping to be rewarded with a fairy prince!

Light and shade

If you wish to give your paintings and drawings a realistic feel, you have to know something about directional light and how it affects the look of your work. As we all know, the sun shines on an object and then creates a shadow behind that object. In order to re-create this in our paintings, we have to remember a few simple rules. If the sun is shining from the righthand side, then the righthand side of the object would be bright and sunny, and the left side would be in shade. The length of any shadow depends on how high or low the sun is.

Watching from the Wood
The central fairy figure is foregrounded and well-lit, while the forest behind her remains in shadow.

Simple light sources

The following examples show how changing the direction of the light source in a painting can affect the mood and look of the image. Use this example as a guide when experimenting with your own work.

 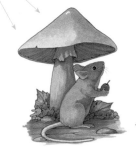 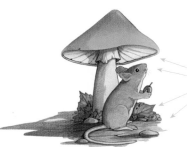

Image without lighting
This image of a mouse under a toadstool has no shading or specific light source. Consequently, the image looks flat and lifeless.

Light source above right
Here, we can see that our mouse and toadstool now have some depth. The image feels more alive. The light source is on the right-hand side, most of the shading is to the left, and the mouse appears to be out in the sunshine.

Light source above left
The picture is exactly the same as the previous one, with the exception that the light is now shining from the left-hand side and the mouse is quite effectively well shaded.

Low light source
If the light source is low in the sky, whether it be the sun or a full moon, it will hit the subject directly from one side, leaving long, dark shadows on the opposite side. Here you can see the low light source on the right with the dark shadows beyond.

Creating form and depth

Depth perception is the ability to visually perceive the world in three dimensions. It allows the viewer to gauge the distance to an object, and it relies on binocular vision (cues that need input from both eyes), but also on many monocular cues (cues from the input of just one eye) to form the final depth perception. Artists use light and shade, as well as many other art techniques, to create a feeling of depth and three-dimensional form in their images to give the viewer the illusion that the canvas is simply a portal into another world as real as our own.

Murky wood
This is an example of how depth can be created using shade and light. Very little daylight reaches into the center of a thick forest, so the more you peer into the trees, the darker the tree trunks themselves appear, giving the impression of depth and distance. Depth can also be created in the opposite way (see the step-by-step project Castles in fairyland, pages 86–87). Depth is created using very pale colors (the castle appears to be far away in the distance).

The color and quality of light

There is a great variety in the color makeup of light that seems white. For instance, sunlight at noon is almost perfectly balanced (all colors in almost equal quantities), while electric bulbs and incandescent lamps produce different varieties of light color.

Morning light

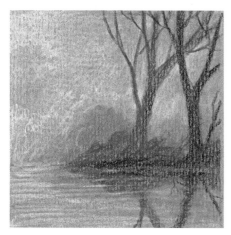

The morning sun can have a much softer feel about it—here, colors are used that soften the mood and give a warming early morning glow. Yellow ocher, terracotta, white, and burnt umber are all soft morning hues.

Sunset

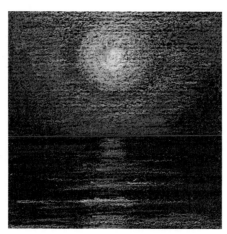

In this simple drawing, you see the glorious colors of a sunset in a darkening sky. The sun itself is glowing quite white with a halo of cadmium yellow, and around that the whole sky begins to turn red and orange. In the water, small ripples appear in reds and oranges, and the reflection of the sun itself can only just be seen in the water nearest to the foreground. Because the sun is so low in the sky, its reflection is cast further away.

Moonlight through the trees

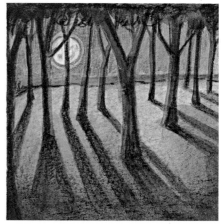

Moonlight is a totally different color from the warm light of fire and sunshine; it is a cool, bluish white. But moonlight can be treated in a similar way to sunlight: the basic light source rules still apply. Here, the moon is very low in the sky and casts long shadows as daylight would. It is shining from the lefthand side of the trees, so everything facing the moon is very pale, with the dark shadows stretching away. Zinc white, ultramarine, Payne's gray, hunter's green, and sepia are the colors used here.

Filtered, dappled light

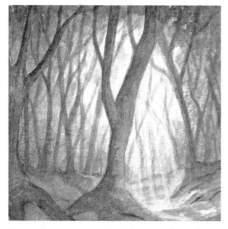

Forests have a magic all their own. They often seem to be obscured from natural light, yet occasionally the sun breaks through the canopy and filters down through the trees, creating an area of soft light. Here we see the dappled sunlight filtering down. Watercolor was used for the basic drawing, and a lot of white paper was left unpainted to mimic the light shining through. The trees in the foreground are darker than those in the background. By leaving the center area quite unpainted, the trees look like they are bathed in an oval of light.

Filtered, underwater light

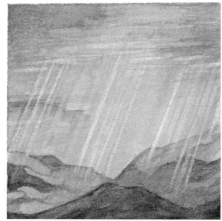

Sunlight in water can be very subtle and soft. Here is an ocean scene showing gentle light shining through deep water. The rocks on the seabed are dappled in different shades of phthalo green, turquoise, and Payne's gray. The surface of the sea has been painted with Prussian blue in varying washes—a paler wash in the center of the picture, with darker washes to the outer edges. A cold-pressed paper was used for this example so that color could be lifted out with a damp brush, creating light rays shining through the water.

Candlelight

Candlelight is difficult to recreate. It is not a consistent light, and its effects can vary considerably. A single candle emits a limited amount of light within a small area and shines strongest at its source; therefore the background soon becomes dense and very dark and the shadows very deep. In this illustration, notice how the light changes upon the surface of the nearest object—the fairy's face—from the white shiny areas of the face, to a red glow, to the very dark shadows in parts of the face that are shaded by the nose or cheeks.

Ready-to-draw file:
Home sweet home

Fairies are very practical, creative creatures, and adapt shells, seeds, and other small, found objects to furnish their dwellings. Fairies might use buttons as plates, twigs bound with twine to make furniture, and scraps of fabric to make rugs and soft furnishings. Here is a sample of a typical fairy tree-root home interior, showing many of the home comforts that fairies might have. Copy these or use your imagination to create other fairy home accents and furnishings.

Toadstools can be used as steps

Curtains made from patched scraps of fabric

Thread-spool table supporting a seedpod lantern

Poppy seedhead wood-burning stove

Walnut-shell crib with patchwork quilt

● Button mobile

Handmade fairy pottery with a blue and white glaze

● Button plates

● Acorn cups or bowls

Puffball toadstools make comfortable seating

Hand-woven grass baskets for storing firewood

● Rag rug made from fabric scraps bound with string

Fireplace made from sticks with a slate hearth and nutshell canopy

● Thimble hanging from a safety-pin hook to heat water

● Button plate

● Woven grass basket

Beechnut shells are used to hold walking sticks and other household items

Snailshell container or vase

Chair made with twigs and wood off-cuts

Matchbox bed

Hand-crafted woodturned cooking pans

Leaf baskets

Chair and table set

● Acorn bowl

● Spider-silk table runner

Horse-chestnut shell bathtub

● Poppy seedhead shower

Creative ideas and transformations

The things that call fairyland home are not the things we see in our everyday world. Use your imagination to visualize, transform, warp, and personify everyday objects, plants, or creatures to populate your unique fairyland with wild and unusual creations all your own! Turn toadstools into fairy friends, give birds butterfly wings, use flowers as trumpets, or draw faces on trees.

Fairyland is full of strange animated beings and unusual flora, so imagine what you could do with all the raw material of everyday life. Constantly draw, doodle, and sketch to conjure up something magical. Start out with little ideas, no matter how vague or undefined, and watch them evolve before your eyes.

▲ **Feline transformation**
Transform ordinary creatures into fairyland beasts and monsters. This monster was painted with acrylic paints. The sly face of the housecat was warped slightly, elongated, and the Cheshire mouth was stretched almost to the ears.

From lizard to dragon

Dragons are a fairyland necessity. They can be tricky to draw, so take time to practice and perfect. An easy way for a perfect dragon every time is to take direct inspiration from nature—it's useful to refer to photographs of crocodiles and other reptiles. Follow this basic exercise to turn an everyday lizard into a fairyland dragon. Using this transforming method you can experiment with different ideas using the base template (it's good fun and will help you improve). Try out a variety of different lizard and crocodile shapes and come up with something all your own.

You will need
- Sketching paper
- HB pencil
- Tracing sheet and graphite paper
- .01 sepia waterproof pen
- Cold-pressed watercolor paper for completed drawings (140 lbs.)
- No. 2 paintbrush
- Yellow green
- Hooker's green
- Yellow ocher
- Scarlet
- Burnt umber

▲ **Trace this**
Draw or trace the lizard onto your sketching paper using the HB pencil. A simple line drawing is fine (you can go over the drawing with your pen if you wish).

▶ **A magical fish**
The fish is quite recognizable, but with the addition of some diaphanous fins and a more pronounced, curved mouth, he is a perfect addition to fairyland.

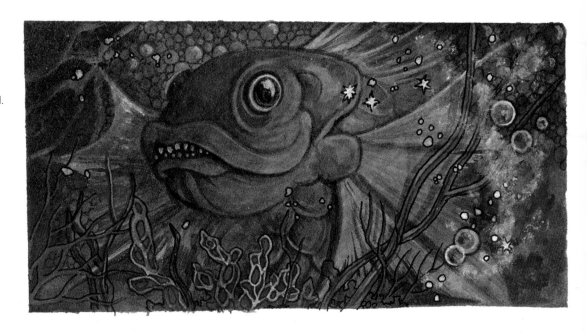

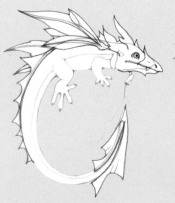

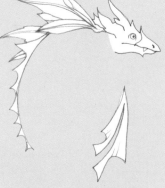

▶ **3. Finalizing your dragon**
Replace the tracing sheet over the lizard drawing and draw around the lizard with your alterations in place, then re-draw or trace the new dragon image, draw over it with your sepia pen, and rub out any left over graphite marks. Add scales, claws, and shading.

▲ **1. Add features**
Place a clean sheet of tracing paper over the top of your template and try out different shapes—draw a larger beak, add some wings and spikes down the back and tail—if you don't like what you have done, simply move the tracing sheet to a clean spot and try something new.

▲ **2. Dragon design**
Here is one dragon design—the tail barb, wing, and face shapes without the template underneath.

▶ **4. Adding color**
Now add some color—using the No. 2 brush, paint a wash of yellow green all over the skin, allowing it to dry before adding washes of Hooker's green to the face, legs, and back, and a little yellow ocher to the underbelly. Add scarlet washes to the tips of the wings, spikes, and tail, giving them a two-tone effect, and add some scarlet to the eye. Finally, color the rock underneath the dragon with burnt umber, and add some burnt umber shading to the wings, underbelly, and face area.

Experiment with this one. Try lengthening the neck and enlarging the limbs—the possibilities for your dragon designs are endless!

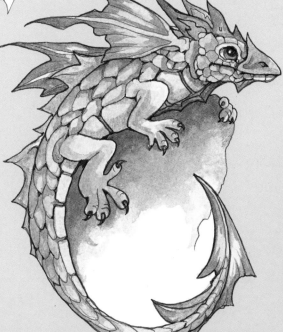

Anthropomorphisms

Fairyland is awash with objects like trees, toadstools, and animals which are found in the real world, but in fairyland these objects are not subject to the everyday rules of real life. Many of them walk, talk, laugh, play jokes, and generally cause mischief (especially the trees!). Use your reference collections to transform ordinary objects into magical fairyland beings with personalities.

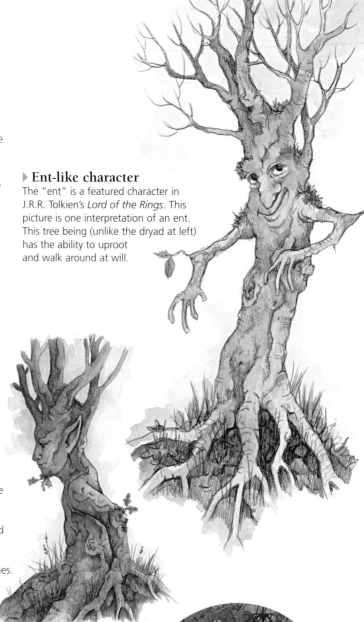

◀ Dryad
A dryad (or tree nymph) is always female. Each one has her own special tree. They have the ability to leave their trees occasionally— usually to dance in the light of the full moon—and are often drawn as half-woman, half-tree. According to mythology, she is bound to her tree for life.

▶ Ent-like character
The "ent" is a featured character in J.R.R. Tolkien's *Lord of the Rings*. This picture is one interpretation of an ent. This tree being (unlike the dryad at left) has the ability to uproot and walk around at will.

▶ Tree spirit
This is a male tree spirit. Unlike the dryad, he is unable to separate himself from the tree because they are both one and the same. His limbs and body form the entire shape of the tree, and his hair is the branches.

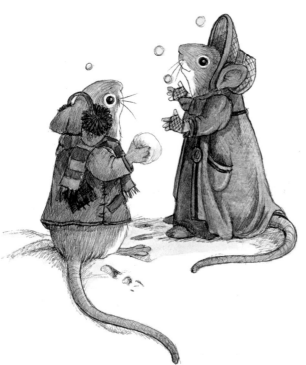

◀ Best-dressed mice
Humanizing creatures is a fun thing to do (and these kinds of friends are common sights in fairyland). Dressing up small, furry animals—such as mice—is reminiscent of the beautiful drawings of Beatrix Potter. All of her characters had personalities (thanks to their clothing). Why not create some well-dressed animals of your own?

▶ The wise old owl
Although owls are supposed to have amazing eyesight, this one seems to need some assistance from his pince-nez glasses as he keeps an eye on a fairy picnic.

Toadstools

Besides being used as fairy dwellings, toadstools can also be turned into great characters. But beware—they are well known in fairyland to be notorious gossips.

▲ **Mother and baby toadstool**
Sketch some wild mushrooms in your notebook. In our world, the tiny, immature toadstools are usually little round blobs—perfect for the faces and personalities of mushroom babies.

▲ **Secretive 'shrooms**
Their eyes peer slyly from under their mushroom caps, and their smirks speak volumes. What have they been talking about? Which fairy has been the subject of their conversation?

▲ **Toadstool goblin**
More man than mushroom, this goblin hasn't evolved completely, however. He still wears his distinctive mushroom cap, but wears shoes and is not rooted down like his fungoid cousins.

Hybrids

In fairyland, ordinary animals are anything but ordinary. It has something to do with the magic of the place: everyday animals start to morph, change, and evolve, taking on the characteristics of other creatures, growing and adapting to the fairy conditions.

◀ **Hummingbird-butterfly**
Jealous of the graceful butterflies all around it, the hummingbird traded in his lightning-fast wings for a pair of colorful, silken butterfly wings.

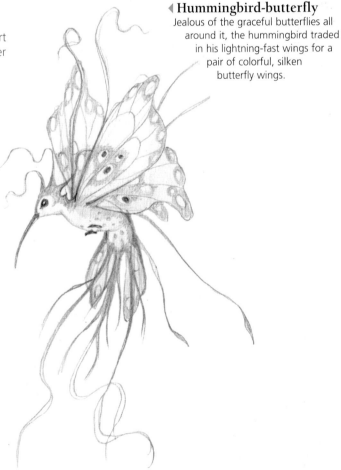

Ready-to-draw file:

Fairy neighborhoods

Not only are fairies proud of their interior design, they are equally fussy about the exterior. (It is always important to impress your neighbors!) Fairies are great craftspeople and natural recyclers (they waste very little), and every found object is likely to be turned into something useful. Coin wrappers for mail boxes, buttons for doorknobs—even the colorful cellophane wrappers from hard candy can be used to make lovely stained glass windows.

There are also a few objects that are found only occasionally and are, therefore, very precious. Thimbles, for instance, are prized for their usefulness, and safety pins are essential to have in any self-respecting fairy homeowner's toolbox.

Window boxes made out of human-discarded popsicle sticks

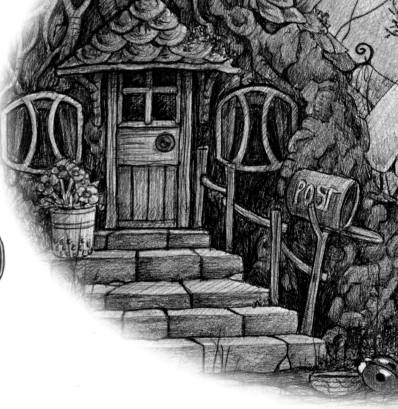

Acorn-cup butterfly feeders are the fairy equivalent of bird feeders (notice the colorful button stepping stones).

Mailboxes are made from coin wrappers (the kind that rolls of pennies come in!)

Similar-sized pebbles are ideal paving stones.

Washing line made from spider's silk

Wooden front door made from salvaged driftwood, with a button for a doorknob and a bluebell blossom doorbell (its ring is inaudible to humans). Matchsticks make good fenceposts.

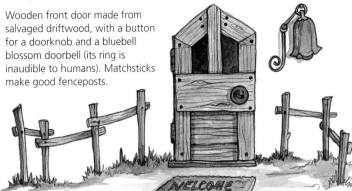

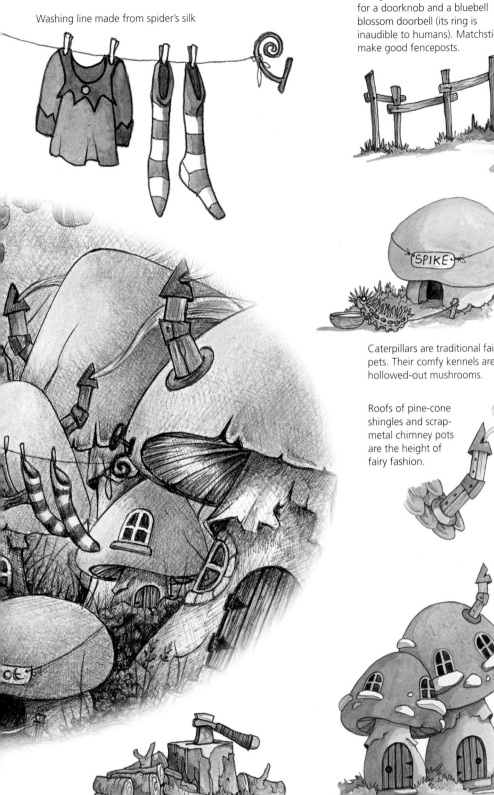

Caterpillars are traditional fairy pets. Their comfy kennels are hollowed-out mushrooms.

Walnut-shell laundry basket

Roofs of pine-cone shingles and scrap-metal chimney pots are the height of fairy fashion.

Thimble flowerpot brimming with forget-me-nots

Stone chips make useful, fairy-size axes, with reinforced matchstick handles.

Although tree-root dwellings are now considered safer and sturdier, the older generation of fairy folk still prefer toadstool homes.

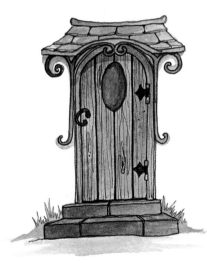

Clotheshanger wire is used to create curly, decorative embellishments for doorways.

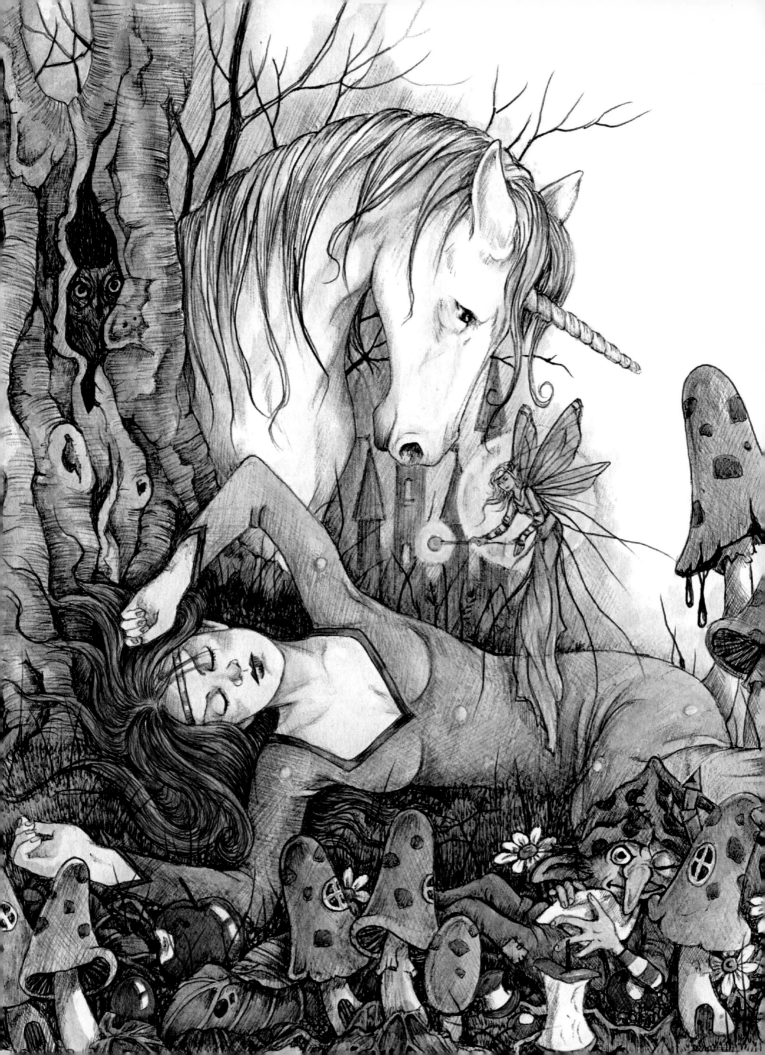

Chapter 3

Inventing Fairyland

In this chapter you'll find a world of exciting, inspirational projects and techniques to try out in your own works of art, including information about the natural world of fairies and their habitats.

Core techniques

Watercolors are a popular medium for painting fairies and other delicate subjects, and they offer many ways to create textures and effects. Explore this selection of easy core techniques. They will all give you great results in a wide variety of fairyland scenes. Start with the basic watercolor techniques, progress through the different media (such as acrylics and pastels), and learn how to use dry brushes, gel-retarding media, film, and liquid masking materials. The other paint media have their own individual characteristics, and provide different results. Use 140lb hot-pressed paper, unless stated otherwise.

Watercolor techniques

By their very nature, wet watercolor techniques are about achieving wet-color blends: anytime two wet colors meet, they will mix. Dry watercolor techniques, on the other hand, use partially dry paint, so the colors are more artist-controlled.

Flatwash
Apply a thin mix of diluted paint in broad, even strokes horizontally across the paper. Use for sky, background, and large, flat areas.

Variegated
With a large, soft brush, horizontally apply thin washes of two colors: one to the top of the paper, one to the bottom.

Wet in wet
Lay a few different colored washes on the same paper. The colors will bleed and blend.

Lifting out paint
Dab wet paint with a tissue or dry brush to lift out some paint. Use this technique to create clouds.

Spatters in wet paint
Create a subtle spatter effect by dropping paint into a wet watercolor wash.

Spatters in dry paint
Spatters can be applied on a dry, washed background as easily as on a wet one. Add white crosses through the dry spatters for stars.

Dry brush (1)
Dab excess (thick) paint off your (thick) brush. When almost dry, dab (don't brush) paint from this brush onto paper. Add colors.

Dry brush strokes (2)
Same as dry brush (1) but brush on paint (don't dab). Great for grass effects. Spatter on white gouache for windblown seeds.

Brush over wet paint

1. Apply a watercolor wash to the paper, and then brush through it with a dry fan-shaped brush before the paint has dried.

2. Add a second layer of watercolor to the previously painted area and brush through with a dry brush before the paint dries, giving a flame effect.

Wash using fine salt

1. Apply a liberal sprinkling of fine salt into very wet watercolor paint.

2. Brush the salt away when the paint is completely dry to leave a soft crystalline effect.

Wash using large crystals

This is the same technique as the "wash using fine salt" (above right), though the larger crystals give a much more pronounced, dramatic result.

Impressing

Run the end of a blunt, wooden object through damp watercolor paint to create grass-like effects.

Rose Thorn Fairy

The fine salt wash technique is used in the background of this painting.

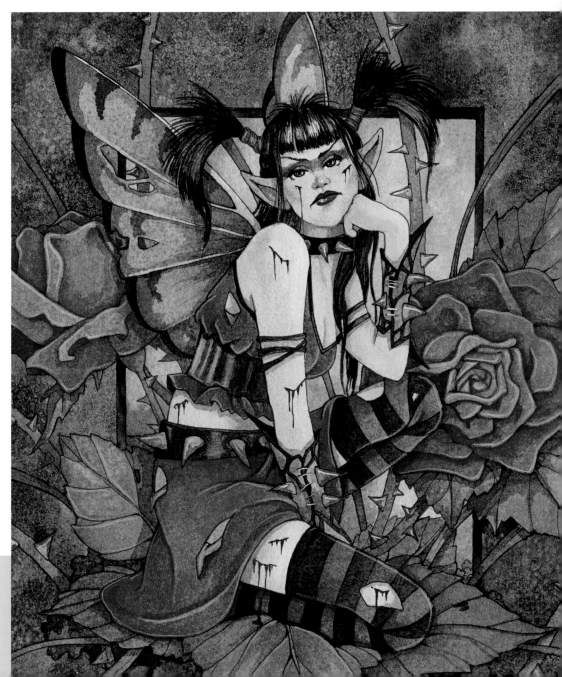

Acrylic techniques

Acrylics can imitate other paints, but they have their own distinct character, too. They are not only great for experimental work, but they are perfect for beginners, for the simple reason that you can overpaint as much as you like without muddying the colors or spoiling the paint surface. Also, by mixing the paint with a gel-retarding medium, you can slow down the rate at which the paint dries, allowing you more time to create a satisfying painting.

Dry brush on wet

Mix three colors of acrylic paint with gel-retarding medium, and apply to paper. Dry brush while wet (this creates a wavy effect).

Blending

Blend a heavy application of acrylic colors quickly for a smooth background (excellent for painting over with opaque gouache, oil pastels, or pale colors like white).

Sgraffito

Add colors of acrylic mixed with retarder medium to slow down drying time, and use the end of a brush to create patterns and swirls in the paint before it dries.

Pastel techniques

Pastels are made by mixing pure pigment together with an inert extender, such as French chalk. Soft pastels are the most commonly used, and offer the largest choice of tints and tones (including some very bright colors). Hard pastels are ideal for blocking in the initial stages of a painting, because they are less likely to fill up the "tooth" or texture of whatever paper or canvas you are using.

Pastel mix

1. Apply a mixture of chalky pastels to pastel paper.

2. Using a soft tissue or fingertips, blend the pastels together to give a soft contrasting background.

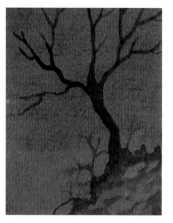

3. Draw a tree into the background using a wash of sepia brown and a No. 2 brush, making a very simple but effective scene.

Masking fluid techniques

There are many uses for masking fluid in fairyland. Magical atmospheric effects can be easily achieved with masking fluid and a few choice colors. Try masking out a lacy filament of lightning across a fairyland sky, or perhaps a sinister devil's-fork bolt crashing down from the heavens into a fairy grove.

Masking fluid is permanent when dry, so use an old brush or coat your paintbrush hairs in petroleum jelly before dipping them into the fluid.

Masking fluid

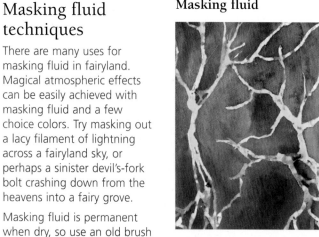

1. Use latex fluid to protect highlights and white areas from paint. Apply it with a brush to the areas that are to be protected, and allow it to dry before overpainting.

2. Once the paint has completely dried, remove the masking fluid with an eraser or clean finger. It rolls away from the paper, leaving clean white lines.

Masking film techniques

Alongside the soft edges of fairyland, the hard shapes produced by masking film and stipple can be highly dramatic.

Masking film and stipple

1. Protect the area with masking film. Using stabbing strokes, apply color to the artwork with a coarse, almost-dry brush that has been dipped into paint. Dab off the excess paint before applying.

2. Once the paint has dried, peel back the masking film.

3. The crisp lines left once the film has been removed are very useful.

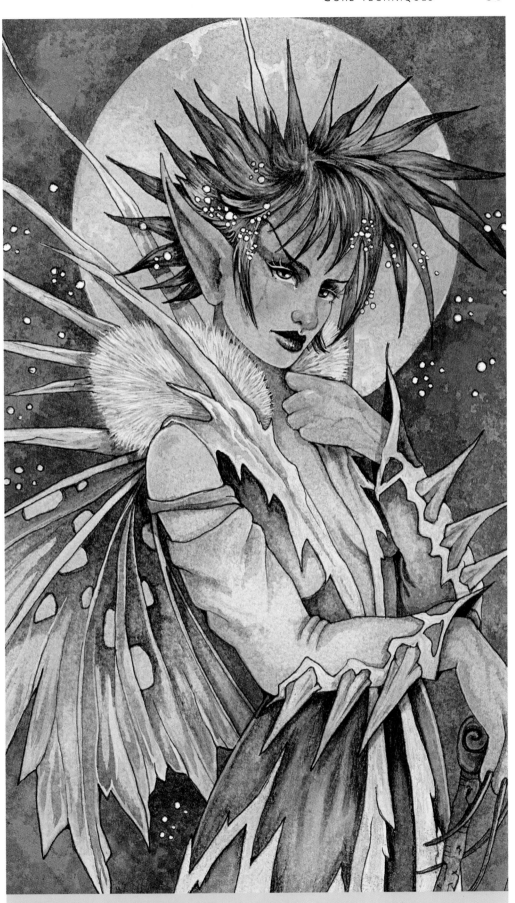

Icicle Fae
The crisp edge of the full moon on the background of this painting was created by using masking film.

Nature's details

Our imagination often takes us to a fairyland firmly in the natural world. Trees, plants, rocks, and pools of water are the natural homes of fairies. They are natural creatures and live in harmony with the rhythm of nature.

Trees

Oak, ash, and thorn trees are traditional fairyland trees. Because of the importance of trees in fairy landscapes, studying them is vital. Create a realistic-looking tree by observing its colors and textures. Tree bark (below), branches, leaves, foliage, and seasonal variations are elements to closely examine.

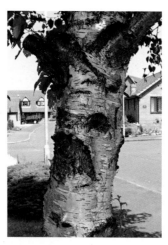

Missing bark
Some trees show a smooth surface underneath where chunks of bark appear to be missing.

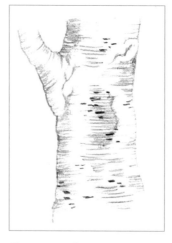

Curves and stripes
Note the banding is not straight but curves around the trunk and branches, giving the impression of a rounded shape. Small, dark stripes on the trunk add realism.

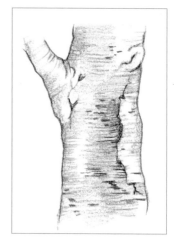

Shading
Add some shading to give the tree more depth. The white and green vertical lines on the right hand side of the trunk look like pieces of loosened bark.

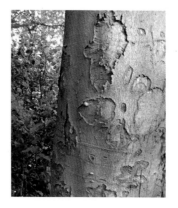

Horizontal banding
Horizontal banding characterizes the surface of tree bark.

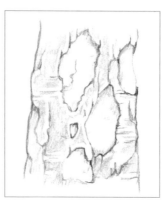

Depth shading
To create a more three-dimensional appearance, add shading with an HB pencil to show where the bark has come away from the trunk.

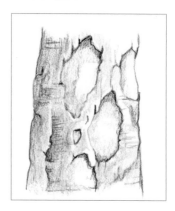

Color and texture
Look closely at a tree's bark and you'll notice how big a part color plays. Use colored pencils to trace and shade close to the areas of greatest texture.

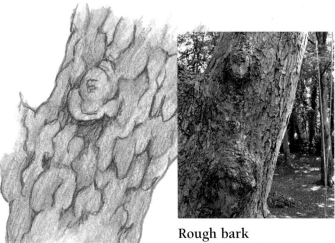

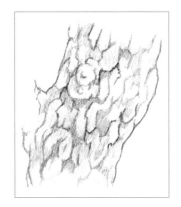

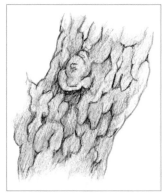

Rough bark
Many tree trunks have a rougher texture and look almost scaly in their appearance.

Scales and pits
Using an HB pencil, place shadows between the scales to suggest the scaly effect of the bark. Shadows will appear to protrude from the tree trunk.

Highlights
Lift the texture of bark further with a little color and more pencil shading. Play with your colored pencils, using ethereal colors reminiscent of fairies.

Silver birch bark

Usually a pale gray or silvery color, silver birch bark is distinctive. It tends to have horizontal bands running through it, which makes it one of the easier types of tree bark to copy. In this example, the copse of birch trees is an imaginary composition—even so, it has some sense of realism and shows that not all trees need to be complicated to be effective.

Build the color
2. In between the horizontal bands, apply the raw umber pencil with horizontal strokes, leaving black to show through.

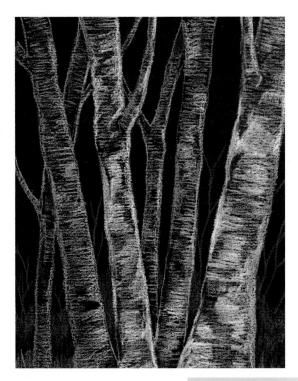

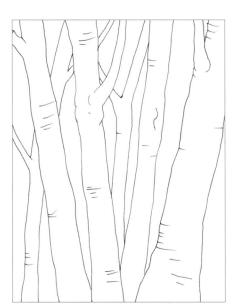

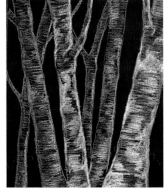

Trace this
1. Sketch with a white colored pencil, applying horizontal bands in a staggered formation along each tree trunk and branch. (The drawing here is reversed for better visibility.)

Add white
3. Add heavier clumps of white and highlights to the edges of the tree trunks and branches. Don't overdo this—make sure you leave enough of the horizontal strokes showing through.

Add color
4. Add a few horizontal strokes of raw umber and sepia brown to the trunks as needed. Simply filling in areas between the trees with olive green and viridian creates the optical illusion of foliage growing in the background.

You will need
- Trace sheet and graphite paper
- Black pastel paper
- **Colored pencils:**
 White
 Raw umber
 Sepia brown
 Olive green
 Viridian

Leaves and foliage

Leaves are the crowning glory of the trees they adorn; you can portray your fairies using them for all types of things from clothing to hiding places. Leaves are very beautiful, and in some cases are quite complex, with their intricate system of veins running through the entire leaf. Some are fine and delicate, while others are thick-skinned and spiky—fall leaves are curled and fragile and can be tricky to paint. It is worth taking time to study leaves as individual subjects before introducing them into your paintings.

Leaf basics

Leaves are hugely valuable parts of a tree: they create food, remove excess water, and acquire oxygen and energy. Most leaves are flat, broad, or shaped like a blade, but some are round, oval, or feathery. The leaves of hardwoods tend to be broad and large, while the leaves of conifers (cone-bearing trees) are usually small and needlelike.

Copper beech leaves
Not as common as normal beech leaves, copper beech leaves shine in the fall, when their bright copper-red leaves really stand out. The beech leaf is a simple shape suitable for beginners.

Aloe or succulent leaf
Thick leathery leaves full of moisture, suited to more tropical climates. Use a range of greens to convey the unique shape.

Pine leaves
Useful in Christmas-themed fairy paintings, alternate between dark and light greens to create a 3D effect in the needles.

Grasses
Grasses can be found all over fairyland in a wide variety of shapes: short and stocky or long and wispy, they are almost always evergreen, with delicate seedheads in the summertime.

Ivy leaves
A fantastic evergreen plant with a lovely leaf shape, ivy can be found in natural settings like forests, woodlands, gardens, or creeping over old brickwork. It's a useful leaf to use in fairy art because it can be found in all four seasons.

Castor oil plant leaf
Although they look tropical, these plants will grow in temperate climates. The leaves are very large, evergreen, and fan-like. The color is green with a slight golden hue.

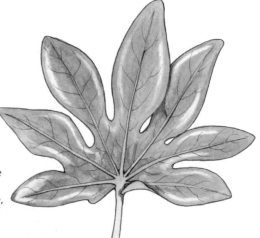

Hawthorn leaves

Hawthorn is a small shrub or tree, and also a member of the rose family. It was hung over doorways in the Middle Ages to prevent entry by malevolent spirits.

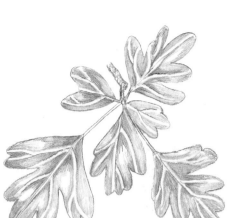

A simple shape showing the formation of the hawthorn leaf.

Trace this
1 Trace the line drawing with your HB pencil.

Add color
2 Add shading on the right-hand side to the entire leaf first. When dry, paint a wash of the same color over the whole leaf (see the left side). Because the shading is added first and allowed to dry, it will become two coats when the wash is added, making it slightly darker than the top coat and allowing the shading to show through.

Leaf shapes and veining

Here is a varied selection of leaves, drawn very simply for you to see the basic veining on certain types of leaf forms. The leaves are (from left to right): holly, sycamore, beech, and ivy. All four leaves are different in shape and structure.

| Holly | Sycamore | Beech | Ivy |

Leaf veins
1. Basic central veining.

Secondary veins
2. On some leaves, the smaller veins lead from the center veins, radiating outward.

Leaf washes
3. Paint colors using a wash to create shading first, then apply an overall wash once the first is dry.

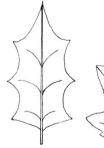
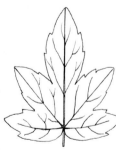
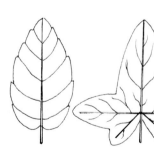
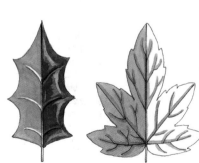
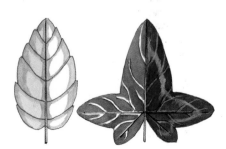

Frosty leaves

Choose fall colors and paint in touches of frost to add a wintery mood to a leafy background. When creating a fairy to occupy the landscape, try a dress edged with frosty cobwebs. Frost will not generally cover an entire object, just the edges and parts exposed to the weather.

You will need

- Watercolor paper
- Selection of fall leaf colors: raw umber, cadmium yellow, cadmium orange, and terra cotta, and deep olive green
- Titanium white gouache
- Watercolor brushes
- Small size 0 watercolor brush for the frost effects
- Sepia watercolor pen, paint, or pencil for leaf veins

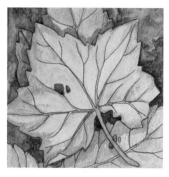

Trace this
1. Trace this template or draw your own leaf outlines with a pencil or a sepia watercolor pen with a size .01 nib.

Applying washes
2. Apply watercolor to the image in fall shades: raw umber, cadmium yellow, cadmium orange, and terra cotta. Fill in the background with deep olive green to give depth to the image. A dark color in the background will make the frost stand out.

Highlights and shadow
3. Add highlights and shading, and finish off the leaf veins using a sepia watercolor pen, paint, or pencil.

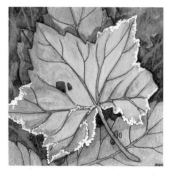

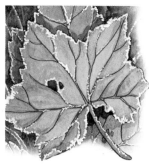

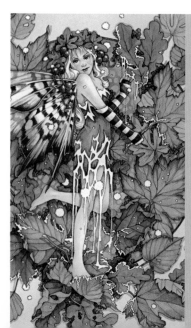

Frost effects
4. Begin to add the frost effect with the gouache. Apply tiny dots along the leaf edges, all around an exposed leaf.

5. Add frost to the edges of the main leaf, some of the leaf's veins, and a few of the other background leaves that would be caught by the frost.

Winter-leaf fairy
The frosting technique is used on the fringes of the fairy's dress and the leaves on the forest floor.

> See also
- Ready-to-draw figures, page 120

Winter branches

Fairyland in the wintertime has sparkling ice crystals, snowflakes, and the magical quality of snow, which dramatically changes the scenery. This quick project for painting snow on branches will help you capture how snow falls and settles on tree limbs.

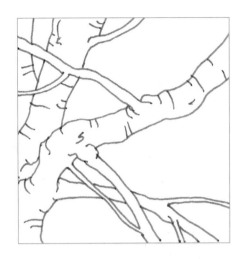

Trace this
1. Copy the template using the HB pencil.

You will need
- •140-lb. cold-pressed watercolor paper
- •HB pencil
- •Tracing sheet and graphite paper
- •No. 2 watercolor brush
- •**Watercolor paints:**
 Payne's gray
 Burnt umber
 Warm gray
 Alizarin crimson

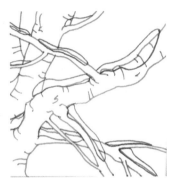

2. The red areas on this template show where the snow will settle. This will help you understand how the snow would cover only parts of the branches (as shown in the next step).

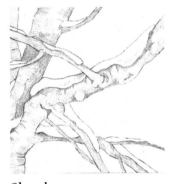

Sketch
3. Make the sketch with the HB pencil to show the branches covered in snow, and add shading to enhance the bark and help to show the snowy areas.

Background wash
4. Apply a Payne's gray wash to the background with the No. 2 brush, and, while still wet, dab a tissue into areas of the wash creating the effect of a stormy-looking sky.

Branch detail
5. Apply a burnt umber wash to the branches only; this will make the white of the snow stand out.

6. More burnt umber wash is applied, but this time only to the areas underneath the snow; this will make the snow look more three-dimensional.

Create shadows
7. Apply a warm gray wash to the underside edges of the snow and the shadows of the branches overlapping the snow. Make sure you still leave the snowy areas predominantly white.

Finishing touches
8. A small amount of alizarin crimson wash is added to the sky to help pronounce the snow and create a colder-looking sky.

Fruits and nuts

This section covers a small selection of fruits and nuts that could be depicted in fairyland. Acorns are a must, because they can be put to such varied and imaginative use; so can the nuts and shells of the horse chestnut. Apples have to be included for their notorious reputation in fairytales.

Apples

Apple trees are renowned for their lush fruit. Adam and Eve were so tempted to taste one that they were banished from the Garden. Often associated with witches and fairytales, and usually sweet and juicy, apples have a desirable quality—but watch out for the sour ones bewitched by magical spells!

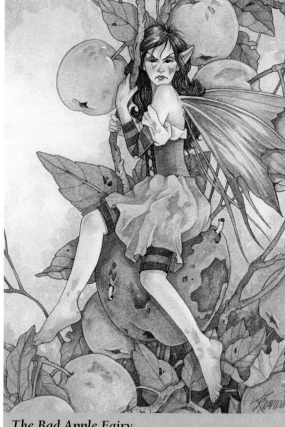

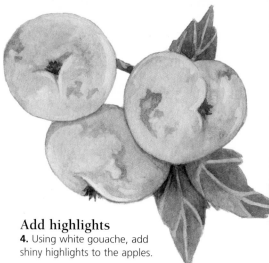

The Bad Apple Fairy
This little fairy is surrounded by apples which convey her mischievous nature by linking her to Eve.

You will need
- HB pencil
- Tracing sheet
 and graphite paper
- No. 2 watercolor brush
- **Watercolor paints:**
 Olive green
 Chrome yellow
 Scarlet red
 Sepia brown
 White gouache

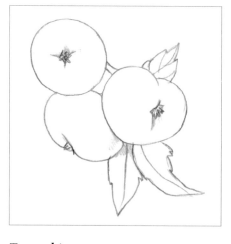

Trace this
1. Trace the template sketch with an HB pencil.

Background washes
2. Use olive green for the leaves and foliage, and apply chrome yellow and scarlet red to the apple in wet-in-wet washes. These apples are yellow-orange in color, but you can experiment with different varieties.

Apple details
3. Paint the other apples using the wet-in-wet technique and adding a little olive green, then apply sepia brown to the apple tops, stem, and shadow between the apples and leaf. When the paint on the apples dries, apply a wash of sepia brown in places to make the apples look a little battered and windblown.

Add highlights
4. Using white gouache, add shiny highlights to the apples.

Acorns

Oak trees are among some of the most magical trees in the world. Some say that there are a few ancient oaks with enchanted gateways that lead straight to fairyland. As the revered fruit of such a special tree, acorns have a multitude of practical uses (such as containers, bowls, and hats) for fairy folk.

You will need
- HB pencil
- Tracing sheet and graphite paper
- No. 2 watercolor brush
- **Watercolor paints:**
 Burnt umber
 Olive green
 Sepia brown

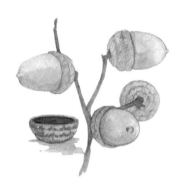

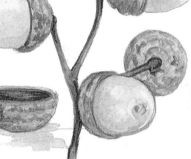

Trace this
1. Trace the acorn shapes and their positions.

Watercolor washes
2. Use burnt umber and pale olive green washes to fill in the acorns.

Shading
3. Highlight the darker-shaded areas with sepia washes.

Horse chestnuts

Horse chestnuts are very beautiful, highly polished looking nuts. Although they are protected by a strong spiky case on the outside, the inside is soft and velvety: perfect for infant fairy cribs, bathtubs, and many other uses. Let your imagination run wild!

You will need
- HB pencil
- Tracing sheet and graphite paper
- No.2 watercolor brush
- **Watercolor paints:**
 Olive green
 Burnt umber
 White gouache

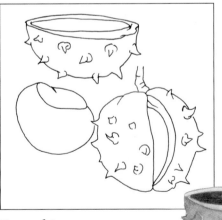

Trace this
1. Trace the line drawing of the horse chestnut and its casing.

2. Apply olive green to the casing, and after the first wash has dried, apply another layer of the same color to the inside of the casing to make it look hollow. Apply a heavy burnt umber wash to the nut, and while this is still damp, use the corner of a tissue to lift out the paint (see the bottom section of the nut). Apply a watered down wash to the lighter top section to ensure it remains paler than the rest of the nut.

Create shadows
3. Use the olive green to create the shading on the left-hand side of the nut casings, and white gouache to make the nut look a little shinier.

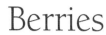

Berries

The fruits of the forest and hedgerows are useful in depictions of fairyland—apart from feeding the woodland creatures and the fairies, they add beauty and detail to any fairyland scene. Berries are rich in color and usually have a shiny skin—it is important to add these highlights to any berries you might paint to make them come to life.

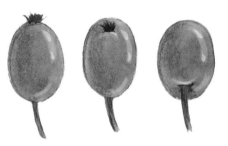

Rosehips

Beautiful, bright red juicy rosehips are very popular in fairyland, with rosehip syrup a firm favorite with all fairyfolk.

Berry perspective
This illustration shows three views of a rosehip berry. As you can see, even though the shape of the berry is the same, by changing the viewpoint, the berry takes on a different shape and appearance.

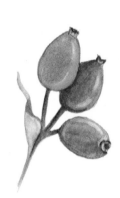

Rosehip clusters
It creates a more realistic appearance when groups of berries are shown from different angles.

Cherries

The perfect accompaniment to any fairy cake, these cherries have reflective qualities that you can capture by adding highlights.

You will need
- HB pencil
- Tracing sheet and graphite paper
- No.2 watercolor brush
- 1 cotton swab
- Watercolor paints:
 Ruby red
 Burnt umber
 White gouache

Trace this
1. Trace this simple template sketch.

Add color
2. Paint the cherries with a ruby red wash, and while the paint is still damp, use a cotton swab to remove a small amount of the paint in the top left of each cherry. This is where the light catches and reflects off the surface. Use a small amount of burnt umber for the stalks.

Depth and shade
3. Once the paint has dried, add depth with more burnt umber to the top and shaded area of the cherries, as well as to the stalks.

Add highlights
4. A tiny amount of white gouache is applied to each of the lighter areas to add that extra shine.

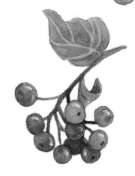

Berry bunches

Berry bunches growing in the wild look very colorful and make a perfect setting for any fairyland scene. Fairyfolk harvest them for winter. Practice this step-by-step sequence to depict berries in a cluster.

You will need

- HB pencil
- Tracing sheet and graphite paper
- No. 2 watercolor brush
- **Watercolor paints:**
 Vermilion
 Alizarin crimson
 Yellow green
 Olive green
 White gouache

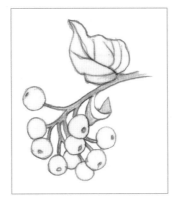

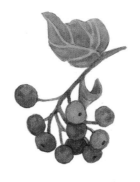

Trace this

1. Berries can often be found in sprays and clusters. When painting these, it is important to make each berry look individual by changing the angles and giving them a natural look. Trace this line drawing of a cluster of berries.

Add color

2. Use a No. 2 brush and suitable berry colors—vermilion, alizarin crimson, and yellow green (olive green for foliage and stalks). Apply washes of vermilion to some berries and, before the wash dries, add a small amount of yellow green or alizarin crimson. Paint unripe berries in yellow green.

Add highlights

3. Allow the paint to dry and then add spots of white gouache to create the shiny highlights.

Blackberries

Blackberries are a sweet favorite with fairies and humans alike. They might be used to tempt an intruder who inadvertently steps into fairyland, so remember never to eat or drink anything there— or you could remain trapped forever.

You will need

- HB pencil
- Tracing sheet and graphite paper
- No. 1 watercolor brush
- **Watercolor paints:**
 Alizarin crimson
 Olive green
 Raw umber
 Lamp black

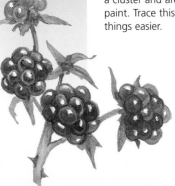

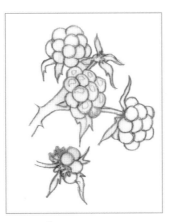

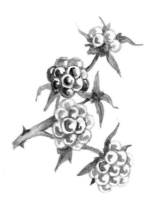

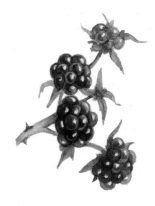

Trace this

1. Blackberries are a cluster within a cluster and are quite difficult to paint. Trace this cluster to make things easier.

Add color

2. Using alizarin crimson and a No. 1 brush, paint around the individual berries and add a small curved highlight to the left-hand side of the berries—this will eventually be the darker area. Use olive green for the leaves and raw umber for the stalk.

Depth and highlights

3. Apply some of the alizarin crimson wash over the berries to fill them in, leaving a small portion of white in each right-hand corner of the berries for the highlights. Add some lamp black to the wash of alizarin crimson and apply to some of the berries—these are the riper parts of the berries and would be darker. Leave some red, too, to add interest (blackberries often have variations).

Flowers

Flowers can vary in degrees of difficulty, from simple daisies to more complicated roses and delicate flamboyant peonies, but at least they do keep still, making them easy to study in detail. If you are not able to use real flowers, you can always opt for silk ones—they are very realistic these days and have the advantage of not requiring water, so they are always available whenever you need to paint them. Even one single flower can be used to make a bouquet, by simply drawing the same flower at different angles and heights.

You will need
- HB pencil
- Tracing sheet and graphite paper
- No. 2 watercolor brush
- **Watercolor paints:**
 Olive green
 Quinacridone rose

Roses

Popular throughout fairyland for its delicacy and fragrance, this queen among flowers is not the easiest to paint, but is well worth attempting. The multiple layers of petals can be tricky, although the bud should be easier to copy.

Trace this
1. Trace this line drawing of the rose, then transfer it to paper.

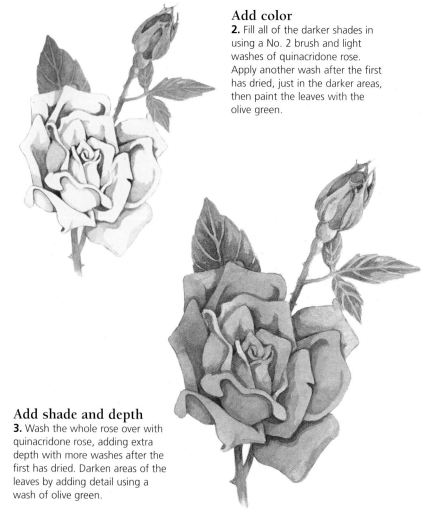

Add color
2. Fill all of the darker shades in using a No. 2 brush and light washes of quinacridone rose. Apply another wash after the first has dried, just in the darker areas, then paint the leaves with the olive green.

Add shade and depth
3. Wash the whole rose over with quinacridone rose, adding extra depth with more washes after the first has dried. Darken areas of the leaves by adding detail using a wash of olive green.

Simple flowers (daisies and forget-me-nots)

Forget-me-nots make excellent hair accessories for small fairy women. Slightly larger daisies can be turned into useful chains for climbing or wearing as jewelry. The shape of these flowers is quite simple and not too difficult to draw. The following steps will help you come to grips with drawing and painting flowers and petals.

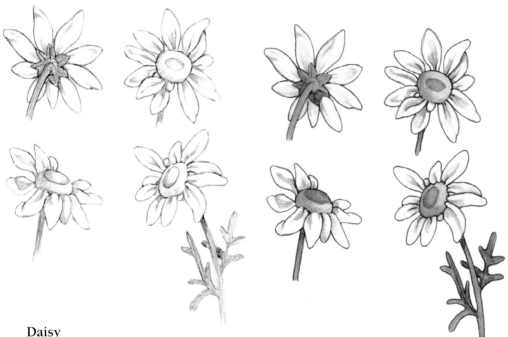

Daisy
This illustration shows a daisy from different angles, showing how looking at a flower from a different viewpoint can change its appearance.

Forget-me-nots
This simple little bunch shows how important it is to draw the flower heads from different angles—the bunch would not have a natural appearance if all the flowers faced in exactly the same direction.

Tropical flowers

Tropical flowers tend to be spiky and very vibrant, and because they are so exotic they are ideal flowers to stylize and change into fantasy blooms. Experiment with your flower drawings, adding long trumpets or long thin stamens. The tropical flowers shown here are imaginary, but are loosely modeled on a bromeliad flower.

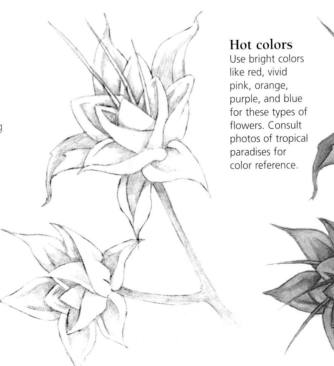

Hot colors
Use bright colors like red, vivid pink, orange, purple, and blue for these types of flowers. Consult photos of tropical paradises for color reference.

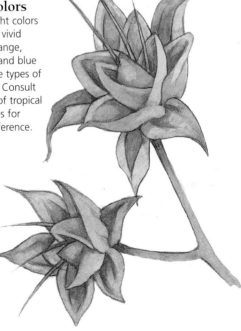

Magic in the air

Delicate seeds, feathers, and fairy dust can be found everywhere in the atmosphere of fairyland. These airy, ethereal elements give a quality of magic, movement, and a feeling of comfort and warmth to your painting. Some seeds, such as dandelions and thistles, almost look like fairies as they dance on the breeze.

Downy feathers

Downy feathers floating in the background of fairy paintings create a soft, whimsical atmosphere.

You will need
- 140-lb. cold-pressed watercolor paper
- HB pencil
- Tracing sheet and graphite paper
- No. 6 and No. 0 watercolor brushes
- White colored pencil
- **Watercolor paints:**
 Payne's gray
 Alizarin crimson
 Titanium white gouache
 (for the feathers)

Trace this
1. Trace the simple formation of the feather shape, then transfer it to paper.

Background washes
2. Apply a wash of predominantly Payne's gray with a No. 6 brush. Add alizarin crimson while the paint is wet to create a swirly effect. You can, of course, create your own background for this exercise, since the feathers are the important part of this technique.

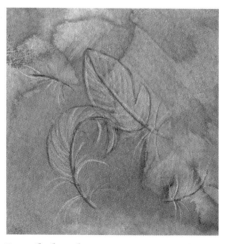

Pencil sketch
3. Using the HB pencil, sketch in the shapes of the feathers. Highlight them with the white colored pencil (especially useful if your background color is dark).

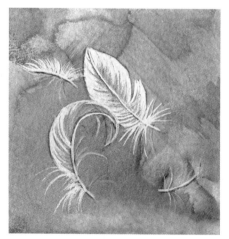

Feather detail
4. Using the No. 0 brush, start to apply strokes of white gouache to the feathers.

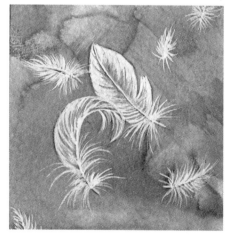

Fluffy feathers
5. Keep applying the gouache until you reach the desired effect. You can add small, fluffy feathers at random with a very simple but effective technique.

Fluffy seedheads

Dandelion seedheads add an airy, magical quality to fairyland, and can be used to convey movement in a painting. This technique could also be used to create thistle heads. Make sure the other background details in your painting match the season in which these seedheads traditionally appear.

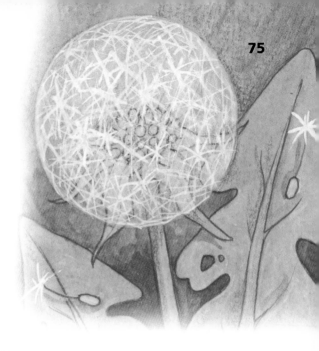

The completed dandelion seedhead should look soft and fluffy.

You will need
- Watercolor paper
- HB Pencil
- Sepia watercolor pen with size .01 nib (optional)
- Selection of watercolors, including olive green, sap green, viridian hue, and raw umber
- White pastel pencil or white colored pencil
- Titanium white gouache
- Selection of good-quality watercolor brushes
- Size 0 brush for creating the seedheads

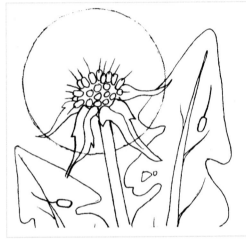

Trace the image
1. Sketch or trace the image, drawing the head in pencil only. Use a watercolor sepia pen with a size .01 nib to draw the rest of the stem and leaves. If you don't have a watercolor pen, draw the image in pencil.

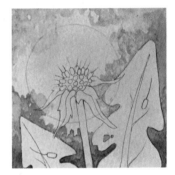

Applying washes
2. Apply a wash of olive green all over the image. Add layers of washes in order to give depth to the background.

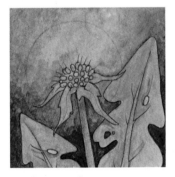

Background
3. Add viridian hue to create some interest in the background. Paint the seeds with raw umber, and use a light sap green on the leaves and stem.

Highlights and shadow
4. Use the the white colored pencil or pastel pencil to highlight the seedhead circle.

Create translucency
5. Fill in the circle with the white colored pencil or pastel pencil, to create the look of a translucent white ball.

Creating texture
6. Mix the gouache to a milky consistency. Paint small crosses over the balls surface with the size 0 brush. Add good-size crosses to the loose seeds.

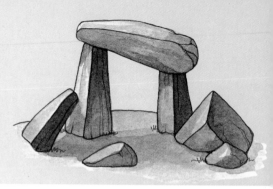

Rocks, stones, and water

Fairyland is filled with lush green forests and trickling, sparkling streams. Here you will encounter magical rocks and stones, dainty fairy seats, and sunny spots for basking in the sun.

Pebbles

Washed-up pebbles form riverbanks, sandy beaches, and even secret rock pools. These are all places where Celtic shape-shifting water spirits like kelpies and water sprites are said to dwell. Unlike mermaids who live in the ocean, these types of fairies prefer inland freshwater habitats or coastal beaches and coves.

You will need
- Trace sheet and graphite paper
- Good-quality sketching paper
- HB pencil
- 2B pencil

Trace this
1. Trace the outlines of the various pebbles using the HB pencil.

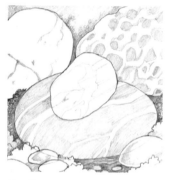

Surface patterns
2. Add in the surface patterns including some shading around the edges. Don't worry if the outlines show through, as they will soon be hidden by more shading.

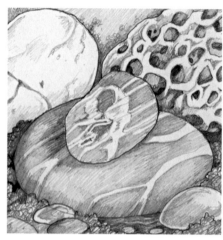

Finer details
3. Notice how the light source in the top right-hand corner casts the darker shadows from the stones to the left. Shade the smaller pebble on top and apply shadows to the surface of the larger rock underneath. Using the 2B pencil, add darker patches to some of the holes in the riddled pebble at the rear to make them look deeper in places. Add a light layer of shading to all pebbles with the HB pencil.

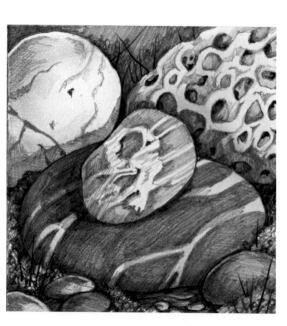

Creating depth
4. Using the 2B pencil, apply your final darker values and overall shading. Deepen the background and add dark tufts of grass for additional visual interest.

Granite rocks

Ancient rock formations all over the world—whether natural (the Grand Canyon) or man-made (Stonehenge)—have fascinated man since the dawn of time. Fairies are frequent visitors to these mystical stones. Masking film and stippled watercolor paint create the granite-like texture of the rock.

You will need

- Trace sheet and graphite paper
- 140-lb. smooth-finish watercolor paper (hot-pressed)
- HB pencil
- Masking film
- Stiff hog's-hair brush
- Paper plate
- No. 2 watercolor brush
- **Watercolor paints:**
 Olive green
 Yellow green
 Warm gray
 Raw umber
 Sepia brown

Trace this
1a. Trace the sketch of the rock formation with the HB pencil, then apply masking film to the entire image, cutting around the sections of the stone shapes (see 1b).

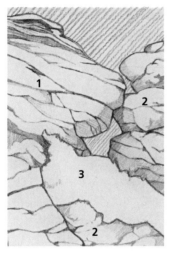

1b. The masking film is removed. The red diagonal lines show the areas of sky that were covered at all times with the film.

First stippling
2. First remove the film over area 1 (see 1b), then use a dry hog's-hair brush to dip into a wash of raw umber. Dry off slightly by dabbing off excess. Randomly apply the wash in stabbing brushstrokes. Once this is dry, repeat with a warm gray wash.

Second stippling
3. Remove the film from the areas marked 2 (see step 2) and repeat the process of stippling using the same color combination as before. Don't worry if you get a little on area 1. This will just add some extra depth.

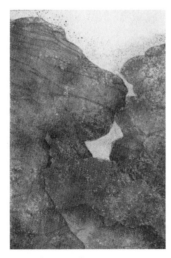

Third stippling
4. Remove the masking film from area 3 (see 1b). Use olive green and a dry brush to stipple the grass onto the painting.

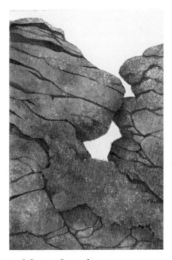

Adding detail
5. Once the stippled brushstrokes have dried, remove the remaining masking film from the sky to leave a crisp edge. Use the No. 2 watercolor brush to add yellow-green details to the grasses and areas of stonework. Apply sepia-brown washes in dark linework to show the layers of the rock.

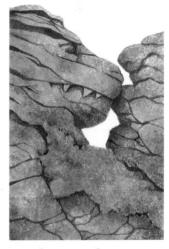

Finishing touches
6. You should now see the profile of a hound (after all, we are in fairyland). As a final flourish, apply some sepia brown to the rock face to give it character.

Reflections

Romantic scenes reflected on water look very beautiful in any fairyland setting. You might even want to depict fairies sitting by the edge of a magical lake. Although this effect may seem difficult to paint, the trick is in knowing how to paint a mirror image.

You will need
- 140-lb. finegrain watercolor paper (hot-pressed)
- HB pencil
- Trace sheet and graphite paper
- No. 2 watercolor brush
- **Watercolor paints:**
Raw umber
Burnt umber
Sepia
Olive green
Sap green

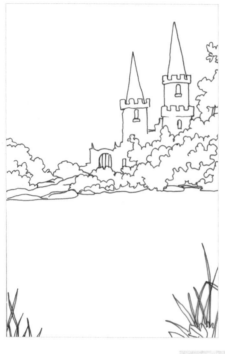

Trace this
1. Trace the sketch of a fairy castle at the edge of a lake with the HB pencil (see page 18).

Reflection line
2. The red line indicates the approximate starting point of the reflection. There is no need to draw this line; it is for guidance only. This will become clearer as we move to the next stage.

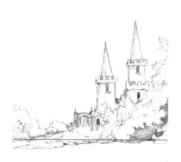

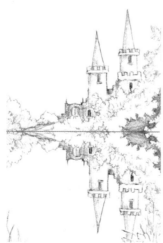

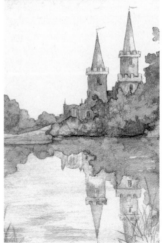

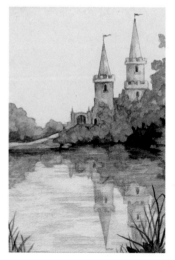

Mirror image
3. Using the red line as a reference, trace over the drawing you have just completed in step 1. This is going to be used as a mirror image to create your reflection.

Trace the reflection
4. Place the tracing directly underneath the original drawing and remember not to draw in the red line since it is for guidance only. Trace the image.

First washes
5. Apply washes to the entire scene. Allow to dry. Apply another wash over the top half to make it darker than the reflection. Brush a very thin wash of raw umber horizontally over the lake's surface to create a watery surface. Detail the castle in burnt umber and sepia brown and foliage with greens.

Horizontal brushstrokes
6. Apply another color wash to the whole painting. Use horizontal strokes when applying paint to the reflected area in order to create the appearance of slight water movement. Add more details and deepen the shading of the top portion to make it stand out a little more from its reflection.

Ripples

Imagine droplets of morning dew gently and slowly dripping into a crystal-clear pool, creating a seemingly endless spiral of ripples. In this exercise you will learn an easy way to create the ripple effect. The scene is imaginary because painting from the imagination is a good skill to have when dealing with legend, but photographic reference material can also be used.

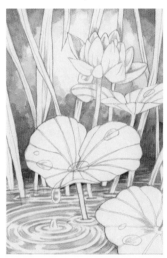

Shading
2. Using washes of olive green, begin to add staggered shading between the ripples and on the surface of the water. Olive green creates the effect of foliage in the background. As it dries, apply extra washes to give more depth.

Trace this
1. Trace the image (see page 18). Add the small semicircle and line in front of each stem as it emerges from the water so it appears as if breaking through the surface and not just sitting on top of it. Draw a number of broken semicircles around the area where the droplets are falling from the leaf.

You will need
- 140-lb. smooth-finish watercolor paper (hot-pressed)
- HB pencil
- Trace sheet and graphite paper
- No. 2 and No. 1 watercolor brush
- **Watercolor paints:**
 Olive green
 Sap green
 Rose madder
 Sepia
 White gouache

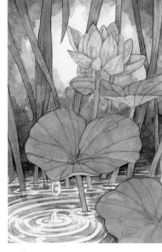

Reflections
3. Paint in the lily pads and rushes using sap green and use rose madder for the flower. Now add a little sap green to the water. Remember that the color of the lily pads reflects slightly in the water.

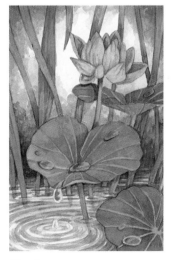

Shadows
4. Shade the lily pads and around the dew drops using sepia. Add a little more sepia to the rose madder to enhance the petal shapes of the flower.

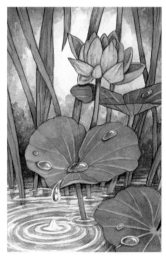

Highlights
5. Finally, use the white gouache to add highlights to the dew drops and water—small amounts here and there should follow the circular shape.

The man-made world

The human footprint on the natural world is unavoidable for fairies. Fairyland exists cheek-by-jowl with the world of man, and sometimes it works to fairyland's advantage. Lonely or disused man-made structures can become hiding places—even homes—for fairy folk. Our world has a direct connection to the world of the fairies.

Wood fences

Cut or painted wood looks completely different than wood in its natural state. Growth rings can be seen when a tree trunk is sliced through horizontally.

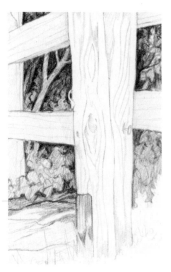

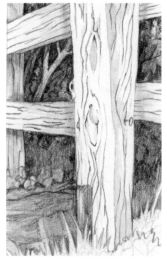

Subtle shading

3. Shade the path and rear shrubbery with the 2B pencil, then add some very dark detail to the knots and lines of the wood.

Add detail

2. With the HB pencil add some finer detailing, such as slight shading to the grain lines, knots, and some background shapes. Make the background darker with the 2B pencil.

Trace this

1. Sketch your wooden fence and wood grain using the HB pencil. Note that the vertical planks have vertical grain lines and the horizontal planks have horizontal grain lines. The oval shapes in the main post give the impression of naturally–occurring knots in the wood.

You will need

- Trace sheet and graphite paper
- Good-quality sketching paper
- HB pencil
- 2B pencil

Create depth

4. Use the HB pencil to shade the entire gate and post, making some of the parts slightly darker than others, including the shading where the wooden joins meet. Use the 2B pencil to finish off any details that require a little more depth.

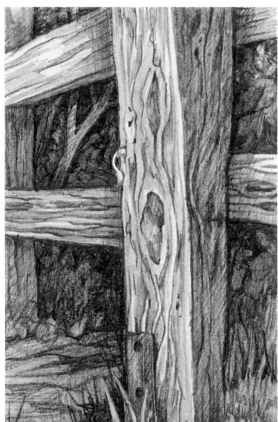

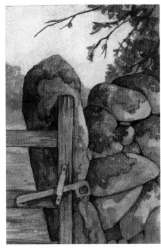

Stone walls

Cracks and crevices in traditional dry stone walls covered in moss and lichen make ideal hiding places for small fairyfolk.

You will need

- Trace sheet and graphite paper
- HB pencil
- 140-lb. smooth-finish watercolor paper (hot-pressed)
- No. 2 and No. 1 watercolor brushes
- **Watercolor paints:**
 Cobalt blue
 Olive green
 Cobalt green
 Burnt umber
 Venetian red
 Sepia brown
 Warm gray (neutral)

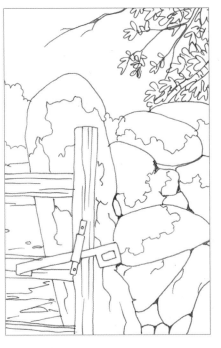

Trace this

1. Using the HB pencil, trace the drawing of the dry stone wall with its wooden gate and latch. Use these lines as a template (see page 18).

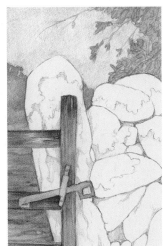

Background washes

2. Using the No. 2 brush, apply washes of color to the background and gate: cobalt blue for the sky, olive green and cobalt green for the foliage, burnt umber for the wooden gate, and Venetian red for the latch.

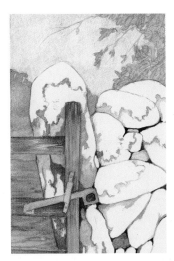

Light washes

3. Apply very light washes of sepia brown to the shadowy areas of the masonry. Add some definition to the wall joints with darker applications of sepia.

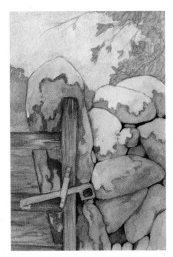

Warm washes

4. Still using the No. 2 brush, cover the whole of the stonework and wall area with light warm gray washes, including those parts to be covered by moss.

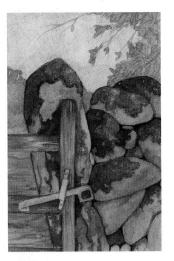

Details

5. To create the look of moss-covered stones, paint a darker shade of olive green and a little sepia in blocks over the stonework. This adds depth and realism to the piece.

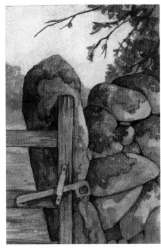

Finishing touches

6. Lay over washes of sepia brown using the No. 1 brush to create extra shading on the left-hand edges of the stonework (with the light source coming from the top right) and underneath the mossy edges, the foliage detail, and the wooden gate.

Fairy environments

From fairy lore and literature, we discover a bounty of places that fairyland is to be found. Obviously, castles have always been favored fairy haunts, and there are many kinds of castles to be found in fairyland. Lake fairies, sylphs, and kelpies call the water their home. All kinds of forests exist in fairyland, from subtropical (see Rainforests, pages 90–91) to temperate groves (see Fairy groves, pages 96–99). Fairy homes can sometimes be identified where there is a large presence of cobwebs. Fairies use cobwebs for hammocks and for materials in their homes (see Home sweet home, pages 48–49). Because fairies are a gregarious lot, fairyland is chock full of feasts and celebrations, often occurring near sacred stones, magical bridges, or other familiar fairy places.

Castles in the air

Imaginary castles in the sky are inhabited by fairies of the air, otherwise known as sylphs. These light and delicate fairies need to have equally light and airy homes, and the ideal medium for creating such an image is soft chalky pastel crayon or pastel pencil.

You will need

- Tracing sheet and graphite paper
- HB pencil
- Pale gray pastel paper with a grained surface (72-lbs.)
- **Pastel crayons:**
 French ultramarine
 Cerulean blue
 Yellow ocher tint
 Gray
 White
- Soft tissue for blending (or just use fingers)
- White pastel pencil

Trace this
1. Trace the line drawing of the castle.

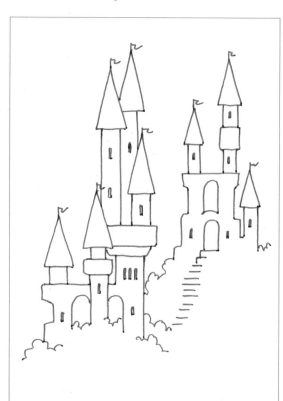

Background definition
2. Apply horizontal bands of French ultramarine (at top) followed by cerulean blue, small amounts of yellow ocher tint and gray at the bottom left corner.

Add the clouds

5. Using soft white and gray pastels, add the clouds, using gentle swirling movements of white at the top and a small amount of gray where the underside of the cloud would be. This will add depth.

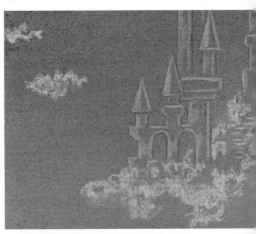

Background blending

3. Gently blend these colors together in a horizontal direction using your fingers or soft tissue paper, until a nice even effect is achieved. You can always apply a little more color if you feel it is needed, again blending in a gentle horizontal direction.

Add the air castle

4. You can either trace the castle template image using graphite paper (which will leave a faint pencil line) or you can draw your own castle freehand with the white pastel pencil. Here the image has been transferred with graphite and then the pastel pencil used to highlight areas of the turrets and castle steps and walls.

Blend the clouds

6. Blend the clouds with gentle circular motions using your fingers or a soft tissue.

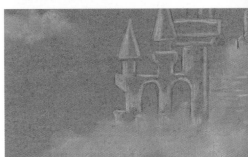

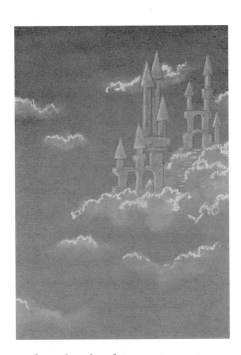

Define the clouds

7. To define the clouds, use the white pastel crayon on the top edge of each cloud.

Shading and depth

8. Blend the white gently into the clouds, then use the HB pencil to add windows and a small amount of shading to the step and turrets. Use white pastel crayon for extra highlights to the castle and small flags.

Thrones in ice castles

Learn to create a fairy ice throne inspired by the Edmond Dulac painting (the artist who painted the Snow Queen illustrations for Hans Christian Andersen's story of the same name).

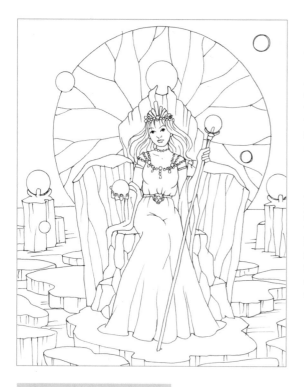

Trace this

1 Trace the sketch of the ice throne. You could use the sketch as inspiration for your own throne by tracing parts of it or trace the whole sketch, then transfer it (see page 18).

Background washes

2. Apply a wash of warm gray to the ice surfaces using the No. 4 brush, then apply washes of raw umber and cobalt blue. Also use the cobalt blue on the dress. The queen's hair is deepened with the warm gray.

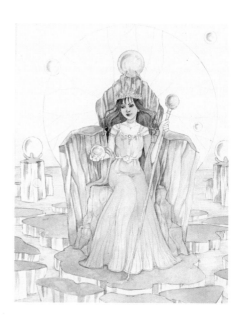

You will need

- Tracing sheet and graphite transfer paper
- HB pencil
- 140-lb. smooth-finish watercolor paper (hot pressed)
- No. 4 and No. 0 watercolor brushes
- **Watercolor paints:**
 Warm gray
 Raw umber
 Cobalt blue
 Dark olive green
 Prussian blue
 Yellow green
 Charcoal gray
 Titanium white gouache

Pencil detail

3. Add some extra detail and shading using the HB pencil—pay attention in particular to the area in the background with the ice pedestals.

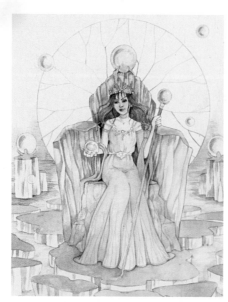

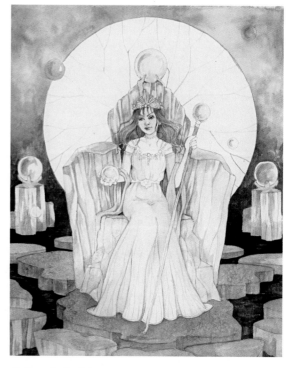

Color definition

4. Use dark olive-green and a No. 4 brush for the water surface, then blend into background. Cobalt blue and raw umber wet-in-wet washes blend into the olive green. Give the ice surface a cobalt blue wash. Scatter salt into the wet paint (rub off when the paint is dry for an ice-like effect).

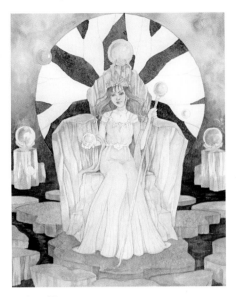

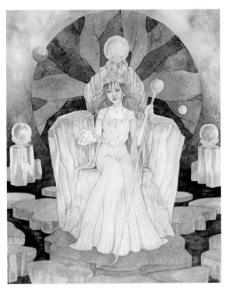

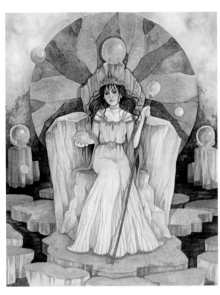

Salt effects

5. Apply a Prussian blue wash, then scatter salt over it. Paint some of the segments in the surrounding circle, and leave to dry before removing the salt, and continuing.

Painting remaining segments

6. Apply a wet-in-wet mix of yellow green and cobalt blue sprinkled with salt to the rest of the segments and let dry.

Color detail

7. Apply a warm gray and cobalt blue wash to the throne and highlights to the floating ice where it hits water. The queen's sleeves, belt, and shoulder straps are Prussian blue (the dress shading and fabric folds, too). The queen's hair, staff, and inner sleeves have charcoal highlights.

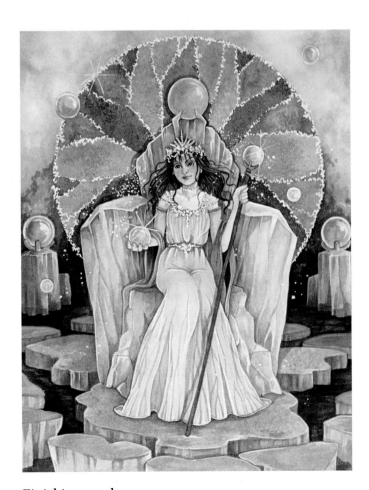

Frost effects

Detail of the Snow Queen's headdress and background: the frost-like effect was created using little dabs of white gouache, which picks out the crown and detail on the dress.

Scepter head

Here you can clearly see how the sparkle was created on the scepter's crystal ball, using fine strokes of white gouache that cross over each other at the center point, creating a star-like effect. You can use this effect on other shiny items such as jewels or stars.

Finishing touches

8. Use white gouache to frost the background with a No. 0 brush (apply small dots to the crown, necklace, and belt). Highlight the floating bubbles, staff, and crystal ball.

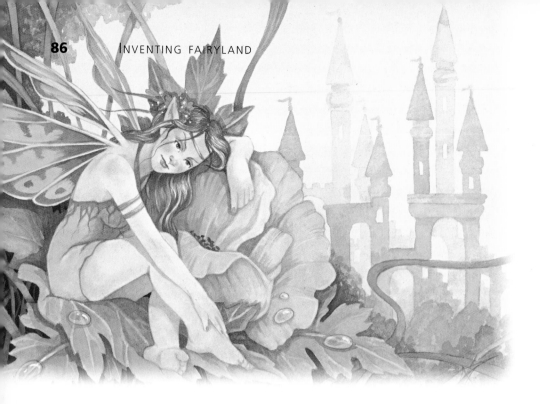

You will need

- HB pencil
- Tracing sheet and graphite paper
- 140-lb. smooth-finish watercolor paper (hot pressed)
- Large soft wash brush, No. 2, No. 4, and No. 1 watercolor brushes
- Black acrylic ink (waterproof when dry)
- **Watercolor paints**
 Olive green
 Sap green
 Viridian
 Payne's gray
 Rose madder
 Raw umber
 Opaque white

Castles in fairyland

Both depth and distance are tackled in this lovely painting. The use of black acrylic ink to create depth in the foreground foliage, along with the gentle washes of watercolor, merges the castle into the distance.

This is a slightly more complicated piece and if you are not confident yet with figures, simply replace the fairy with flowers from some of your own reference material.

Trace this
1. Trace the line drawing, then transfer it to paper (see page 18).

Pencil details
2. Add details using the HB pencil, omitting the background shading, yet showing the details in the leaves and dress.

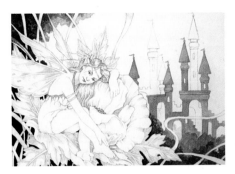

Background color

3. Carefully apply the black acrylic ink to the background in the darkest area of the painting with a No. 2 brush. Apply dark olive-green watercolor at the edges of the flower and leaves at the top left and bottom right of the painting, and blend them into the acrylic with a No. 4 brush. Blend a lighter wash of olive green near the castle.

Green detail

4. Paint the leaves with the olive-green wash (and a hint of sap green mixed in to brighten it a little) with a No. 4 brush. Using a watered-down version of the same color, paint the more distant part of the castle. (Note that the farther away the castle is, the paler it will become as it fades into the far distance.)

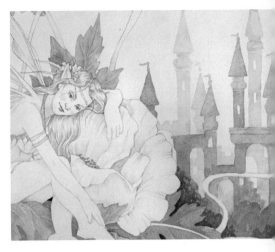

Green wash

5. Using the large wash brush, mix up a thin wash of olive green and sweep it evenly across the entire painting.

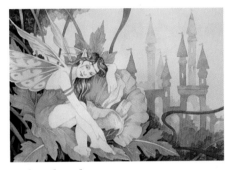

Color details

6. Once this wash has dried, add more details with a No. 2 brush, add viridian to the fairy's dress, wings, and hair, together with the background grasses. Brush her hair with Payne's gray. Apply washes of rose madder to the flower in vertical strokes to create the petal's creases. Apply washes in the darker flower folds as the paint dries.

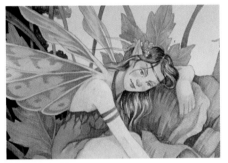

7. Add rose madder washes to the wings—here they are partially painted—and add a little of the rose madder to the fairy's face, nose, and lips. Add a wash of raw umber to the fairy's skin, to give a slightly more tanned, lifelike appearance. Apply a small amount of olive green to parts of the leaves under the flower ready for the next stage of shading.

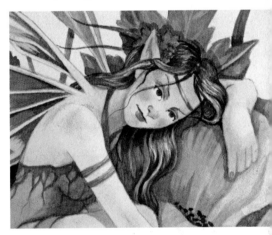

Create shadow

8. Apply hair color with Payne's gray and a No. 2 brush, extra detail to the flowers in her hair with a dark mix of rose madder, and fairy wind details with a mixed wash of Payne's gray and rose madder. Payne's gray and viridian are for shadows. Add shading to the leaves and grass.

Finishing touches

9. Add a little rose madder to the fairy's skin to add a rosy glow, and opaque white to her eyes and hair. For the dewdrops, draw simple oval shapes onto the leaves using the No.1 brush. Using the opaque white, add a little white to the side of the oval shapes to give the look of white shining light, and add a light shadow with the Payne's gray and viridian mix.

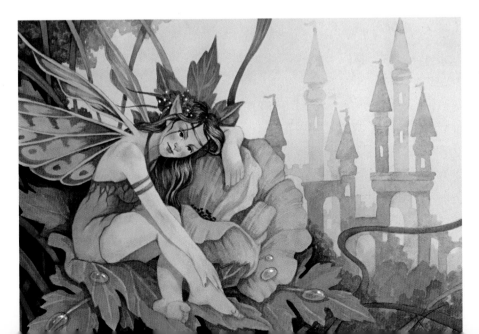

Underwater

The water sprites are possibly a distant relative of the mermaid. They live in our freshwater pools and streams, and this particular painting is of a very mischievous little sprite. There are many ways to paint underwater scenes—this method is a simple technique using salt scattered into wet color washes, and white gouache creating underwater bubbles.

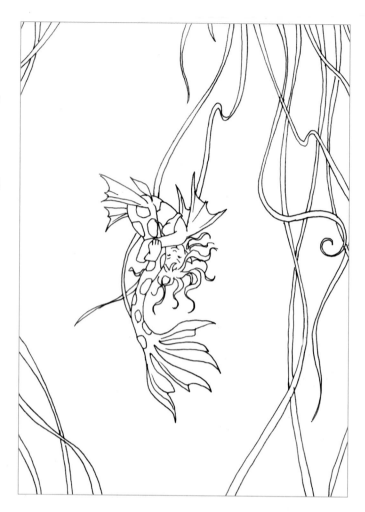

You will need
- HB pencil
- Trace sheet with graphite paper
- 140-lb. cold-pressed watercolor paper
- Fine sea salt
- No. 30 wash brush (these are quite expensive to buy but well worth it if you paint with watercolors frequently)
- No. 2 and No. 0 watercolor brushes
- Stiff bristle No. 8 brush
- Watercolors:
 Olive green
 Prussian blue
 Ultramarine
 Payne's gray
 White colored pencil
 White gouache

Trace this
1. Trace the sketch of the underwater sprite, then transfer it to paper (see page 18).

Background washes
2. Once you have made your drawing or sketch, apply thin wet-in-wet washes of olive green, Prussian blue, and ultramarine to the entire picture. While it is still very wet, scatter on the salt crystals and leave to dry. Do not touch the painting until it is completely dry.

3. Once the crystals have been rubbed away from the dry paint, you will be left with a wonderful crystalline effect—the drawing underneath should just about be visible. Use a dry stiff bristle No. 8 brush to dab on some olive green in the top portion of the painting.

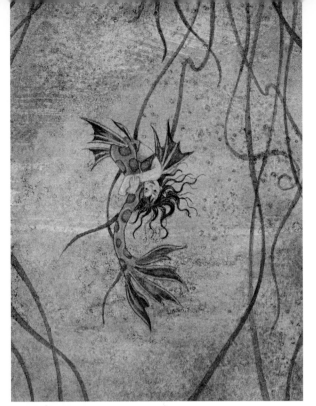

5. Using a circular template or coin, draw in some round shapes using the white colored pencil—these will be the bubbles floating in the water. Don't forget to add small highlights to each one.

6. Add a hint of Prussian blue wash to each bubble in order to make them stand out a little more.

Add detail

4. Using the HB pencil, redraw the figure and pond weed so that it is more visible and easier to work on. Using the No. 2 brush, begin to paint in the detail—the sprite's hair and fin tips with Payne's gray, the tail with a wash of Prussian blue, and olive green on parts of the fins and pondweed. Once the color is added, the drawing begins to come back to life.

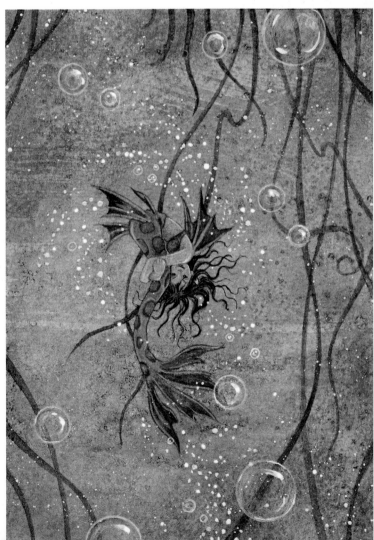

Add highlights

7. Add highlights to the bubbles and parts of the little sprite's shoulders and tail with white gouache and the No. 0 brush. Using the spatter technique, dot areas of the painting with a white gouache mix, but try to avoid the figure of the sprite—you can always place a piece of wadded–up tissue over the area you want to protect.

Finishing touches

8. This little sprite is obviously having fun and doing some underwater acrobatics. To add that extra flourish and give some movement to the painting, use the No. 0 brush to add individual spots of white gouache all around the figure.

Rainforests

This tropical scene demonstrates that even when using pale colors, you can still effectively create depth and distance. The drawing itself has been made with a .01 waterproof sepia ink pen, though the large leaves in the distance have been drawn with an HB pencil; this helps keep them in the distance when they have been painted. The overall feeling is lush, hot, and tropical.

Trace this
1. Trace the image, then transfer it to watercolor paper (see page 11). Use waterproof pen to ink in the fairy and exotic flowers, and a pencil for the background leaves.

You will need
- Tracing sheet and graphite transfer paper
- HB pencil
- 140-lb. smooth-finish watercolor paper (hot-pressed)
- .01 sepia waterproof pen
- No. 4, No. 2, and No. 0 watercolor brushes, large soft wash brush
- **Watercolors:**
 Yellow green
 Olive green
 Viridian
 Vermilion
 Payne's gray
 Raw umber
 Rose madder
 Opaque white

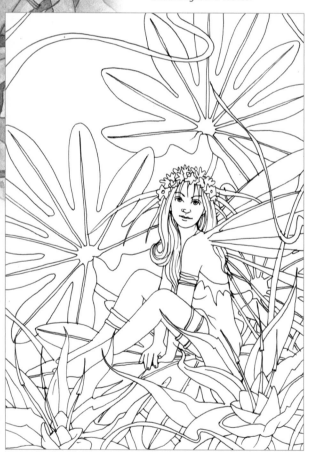

Background washes
2. Using the No. 4 brush, apply a diluted wash of yellow green to the large tropical leaves and wait for this to dry completely before progressing to the next stage.

3. Mix up a quantity of olive green wash, load up the large wash brush, and, using quick but gentle sideways strokes, evenly cover the entire picture with a pale green wash. Allow to dry thoroughly.

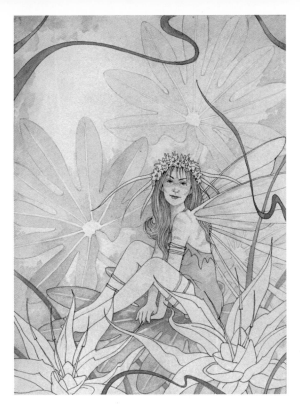

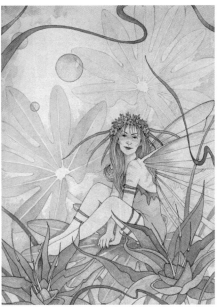

Color details

5. Apply more olive green to the fairy's leaf, parts of the fairy's headdress, gown, and arm/leg bands. Paint washes of vermilion onto the exotic bromeliad flowers and fairy's mouth, headdress, and wings. In the top left hand section add a few bubbles filled with a light vermilion wash, leaving a small section clear for a highlight.

4. With the No. 2 brush, apply light viridian washes to the background to create a subtle foliage effect. Also apply this wash to the fairy's dress, hair, and part of her wings. Use a slightly darker wash with a small amount of olive green on the grasses, and under the fairy's legs as shading on the leaf. (The darker washes are at the front of the painting, becoming lighter as they recede into the background.)

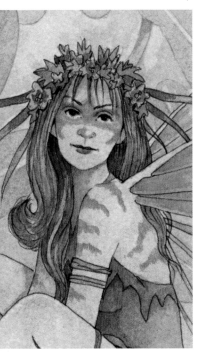

Color definition

6. Apply washes of olive green to the fairy's leaf, outfit, and sections of the background leaves (to define their veining and shape). Use yellow green to define her decorated clothing and the shading in her wings. Vermilion brightens up the fairy's headdress and lifts the color in the flower parts. Add a little Payne's gray and viridian to the fairy's hair, and some subtle shading on her arms and body. Apply a light wash of raw umber to her skin for a healthy look.

Finishing touches

7. Apply a little rose madder wash to areas of the fairy's body to give her a rosy glow—it is clearly visible on the shoulders, knees, and cheeks—and add more Payne's gray and viridian to her hair, making it much richer. Add vermilion highlights to her wings and headdress, helping lift her forward within the picture. Finally, add the opaque white highlights to the bubbles and around the headdress.

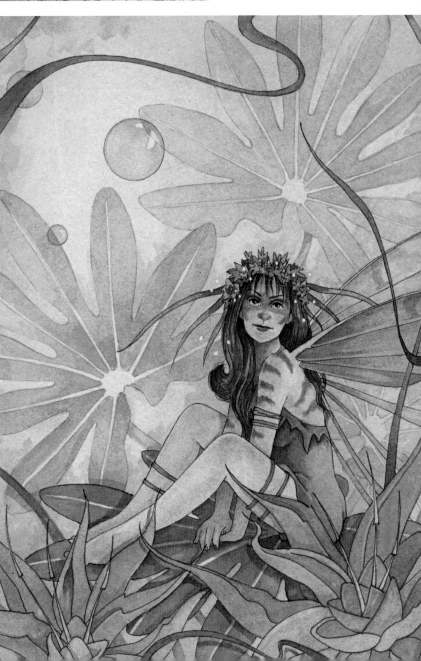

Fairy tree homes

The photograph below left is the inspiration behind the tree root home. In the second photograph, you can see how the drawing fits in with the original picture. You, too, should explore your imagination: go out and find a tree root that may be suitable inspiration for a fairy home. I enjoy using simple ballpoint pens to draw and sketch, although they take a little getting used to; practice a few strokes beforehand, applying more pressure for darker areas and cross hatching for shadows and depth.

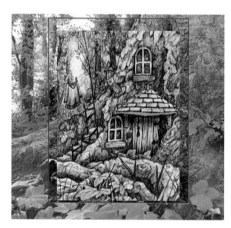

You will need
- Tracing sheet and graphite paper
- HB pencil
- Good-quality, white sketching paper
- Black ballpoint pen
- Selection of colored pencils in varying shades of browns, greens, and a little red

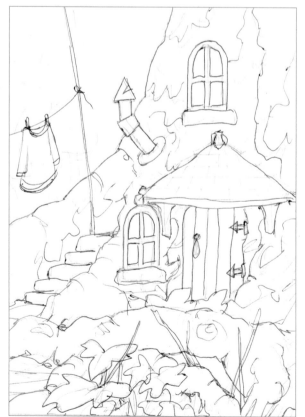

Trace this
1. Trace over this quick pencil sketch. Don't worry about making mistakes—any pencil lines will disappear at the end of this sequence. Transfer the image (see page 18).

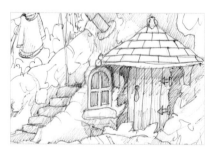

Add definition
2. Go over some of the basic lines on the sketch and start to add some light diagonal and horizontal pen strokes to the areas on the drawing which will eventually have some shading.

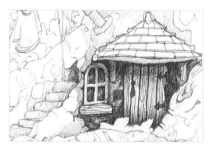

3. Using heavier pressure on the pen, start to shade in the doorway and window—the slightly lighter parts are left paler by applying lighter pen strokes.

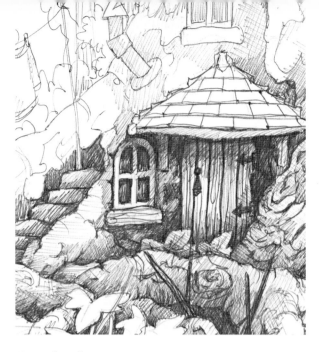

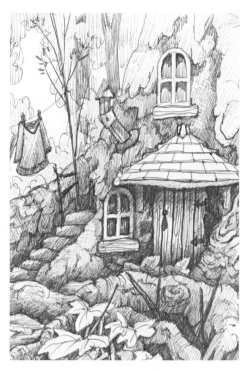

5. Continue to cross hatch over the bark and up toward the top of the house—use light strokes at first, as you can always add more variation with darker strokes if and when you need them.

Cross hatching

4. Use cross-hatching strokes to work on the tree roots in the foreground and the little steps, with darker, heavier strokes used for the shading underneath the roots at the bottom and in between the leaves.

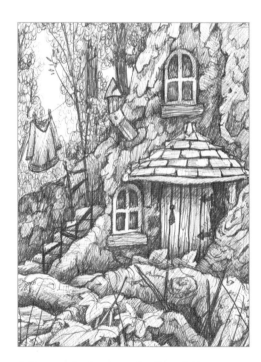

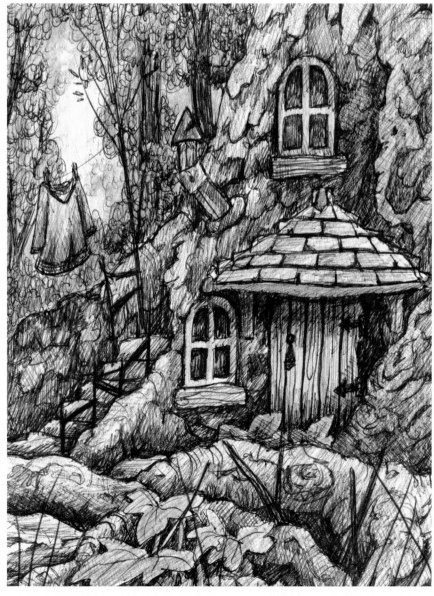

6. Keep gently drawing, using those light cross-hatch strokes—the more you apply, the darker the area becomes. As you can see, the foliage in the background has been lightly scribbled in circular motions, creating the look of distant leaves. When you are happy with the general look of the picture, you can add some extra details using very heavy dark pen strokes—see the fencing around the steps and grasses in the foreground.

Adding color

7. Using your selection of colored pencils (or watercolor wash if preferred), add a little dash of color to the drawing—this gives a traditional feel to the whole illustration, reminiscent of Victorian fairytale books.

Mushroom villages

Mushrooms make excellent homes for tiny fairyfolk. There are so many types of toadstools and mushrooms—in all shapes and colors—that your imagination can run wild with ideas for these magical homes. In this section I hope to give you some inspiration and ideas to create your own fairyland village.

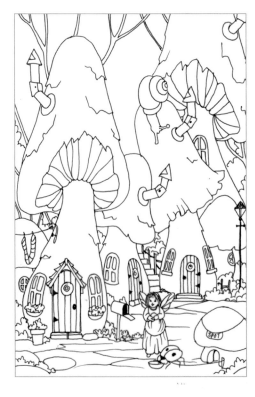

Trace this
1. Trace the sketch of the mushroom village, then transfer it (see page 18).

You will need
- •HB pencil
- •Tracing sheet and graphite paper
- • 140–lb. smooth-finish watercolor paper (hot-pressed)
- •No. 4, No. 2, and No. 0 watercolor brushes
- •**Watercolors**
 Olive green
 Raw umber
 Alizarin crimson
 Sepia brown
 Burnt sienna
 Lamp black
 Cadmium red
 Cobalt blue
- •**Chalk pastels**
 Payne's gray
 White
- •Thick yellow paint

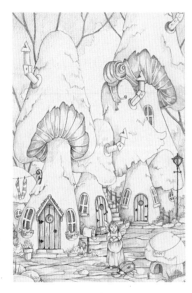

Add detail
2. Add shading using the HB pencil—this sketch is now ready to paint.

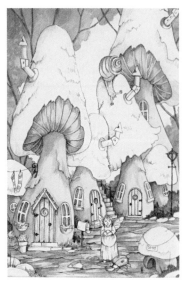

Background washes
3. Using the No. 4 brush, apply washes of olive green to the background foliage areas and village floor. With the same brush, apply raw umber washes to the main bodies of the mushrooms.

Color details
4. Add alizarin crimson to mushroom caps (No. 4). Wash sepia brown over twigs, posts (No. 2). Olive green for leaves, pale sepia for doors, ground, and chimney pots.

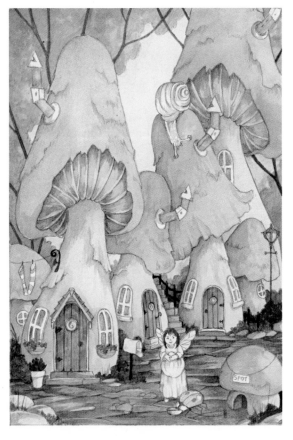

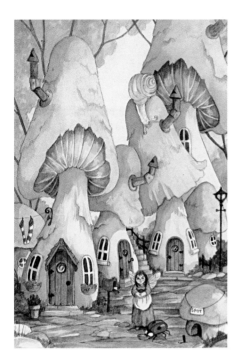

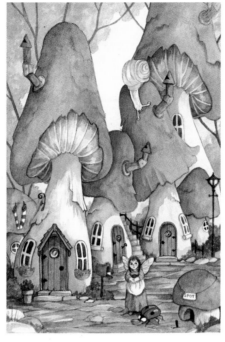

Pale mushrooms
5. With the No. 2 brush, use a heavy, raw umber wash for the doorways, snail shell, and chimney pots; burnt sienna for the flowerpot, lamp black for the windows, chimney shadows, lamp-post, and doorknobs; red for the pet ladybug; and cobalt blue for the fairy's dress.

Mushroom wash
6. Apply a wash of raw umber with the No. 4 watercolor brush, and while this is still wet, add a wash of alizarin crimson so that both shades blended together create a much brighter look, giving them an almost rusty appearance.

Finishing touches
7. At this stage the painting is quite complicated and any further additions are not that noticeable. You can paint an olive green wash over the ground, add an extra coat of sepia to make the fairy's hair darker, and add the stripes to the little snail on top of the third house. Add delicate flower details with fairly thick yellow paint to the village greenery, and finally, using the gray and white pastels, draw smoke trails from the chimney pots, blending them gently with your fingertips.

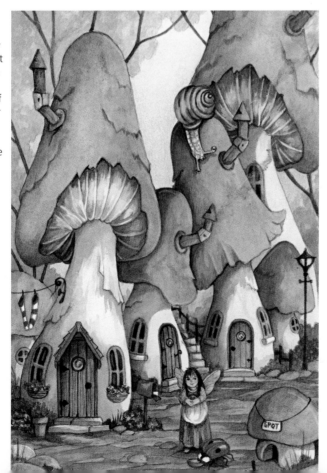

Funky fungi
Once you know the basic shapes, you can use your imagination to design your own brand of funky mushrooms and toadstools.

Tree bark fungi
These are the type of fungi which attach themselves to tree trunks, and can often be seen on fallen trees and branches. You could create your own color schemes for these fungi that would add an extra element of interest to your painting.

Fly agaric
The fly agaric toadstool is one of the most commonly portrayed fairy toadstools—its beautiful bright red color and little white markings add a touch of fun to fairyland paintings.

Shaggy ink cap
The shaggy ink cap is quite often seen in clumps and is a tall slim shape—perfect for background interest. It gets its name from the black inky substance that oozes from the cap as it ages and decays—a good candidate for a sinister goblin scene.

Puffball
The puffball family is quite a bizarre group—they form in little clusters of round ball-like shapes. The spores are literally puffed out of the ball as it dries out and ripens—it is worth looking these up in a reference book.

Toadstool cluster
Toadstools and mushrooms can sometimes cluster together—this example only shows a few huddled together, but they can be found in great numbers.

Fairy groves

These sacred places lie deep within the darkest forests. Ribbon offerings hang from tree branches that surround ancient carved stones, hiding them from prying eyes. Use the drawing as a template to try this technique, or find a photograph to use as a starting point for your own original work.

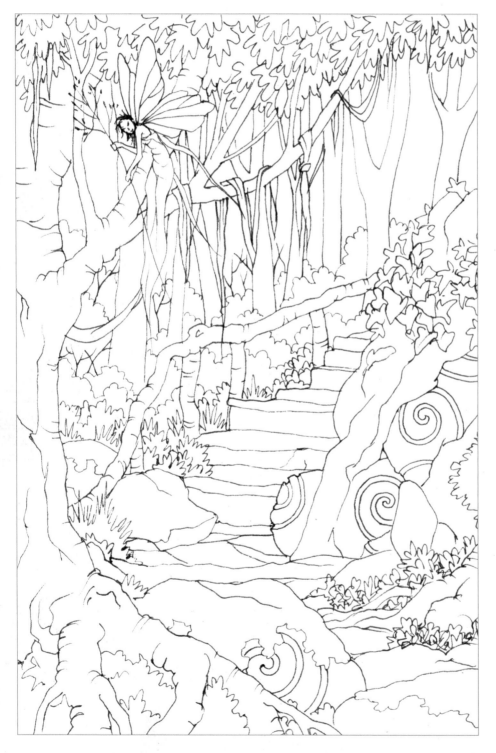

You will need

- HB pencil
- Trace sheet and graphite paper
- Sepia fine line pen .01 nib (waterproof pigment ink)
- 140–lb. smooth-finish watercolor paper (hot-pressed)
- Soft eraser
- No. 2 and No. 1 watercolor brushes
- **Watercolors:**
 Burnt umber
 Olive green
 Permanent green
 Warm gray
 Yellow green
 Hooker's green
 Lamp black
 Ultramarine
 Magenta
 Cadmium orange
 Cadmium yellow
- White colored pencil
- White gouache

Trace this

1. Trace the template drawing, then transfer it to watercolor paper (see page 18). Draw the image using a fine pencil line then, using the ink pen, draw around the lines, making any corrections. When this is complete, wait a few minutes for the ink to dry properly, then remove the pencil lines with a soft eraser. To make it easier to add the paint, shade some of the darker areas with pencil—it helps to define the trees and steps. Draw a faint circle around the fairy figure (a template for her aura).

Background washes

2. With the No. 2 brush, fill in the tree trunks with a burnt umber wash—the further back they are, the darker they should be—then apply a wash of olive green to the rear foliage, and a wash of permanent green to the leaves at the top left. Make sure that you take care around the fairy figure—paint inside the circle with very pale washes, applying darker washes round the outside. This leaves a faint circle effect all the way around the figure (see detail, right).

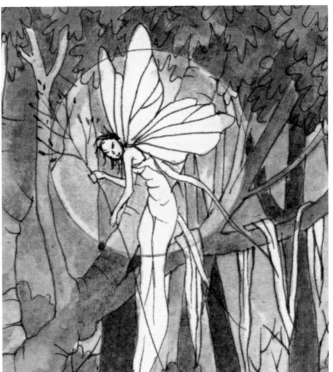

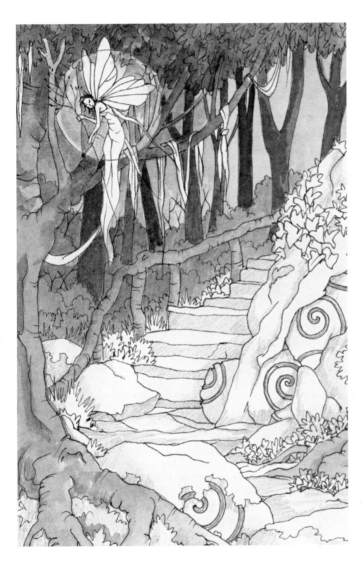

Color details

▶ **3.** Remove the circle around the fairy with an eraser and apply washes. Warm gray and olive green for the stones and mossy boulders, olive green with yellow green to highlight the foliage by the steps, olive green for the tree's undergrowth, Hooker's green for ivy. Fill in the steps with warm gray and lamp black. Mix ultramarine and magenta for the ribbons.

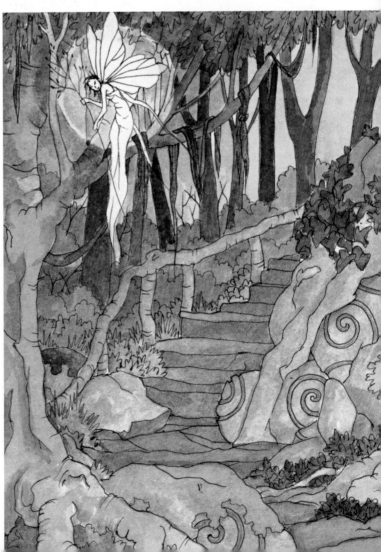

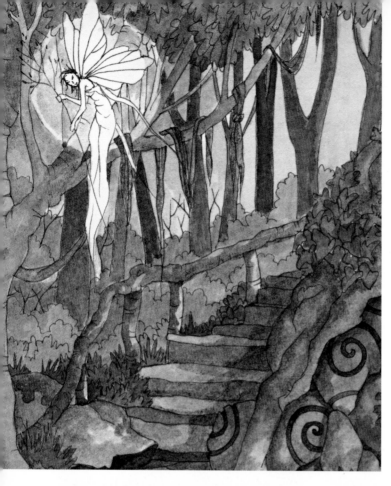

4. Apply more of the same washes to the drawing, allowing each one to dry before adding more color. This will create more depth. Do not add any more paint to the fairy figure; you can see how she stands out from the background as it becomes deeper with color. Use lamp black and warm gray to fill in the shaded areas on the steps and trees, and to outline carvings on the rocks.

Without pen definition With pen definition

Detail definition

6. In order to define all the detail in the painting, draw around the entire image again, using the pen to emphasize the very dark crevices and shadows. This makes the entire image very dark, creating a more intense atmosphere.

Create a glow

5. Create an orange glow by applying a wash of cadmium orange to the distant skyline above the foliage, and apply cadmium yellow to the figure with hints of the cadmium orange to make her glow and stand out from the painting. If you wish, you can stop the painting at this point and go to the final step (see detail for fairy glow above).

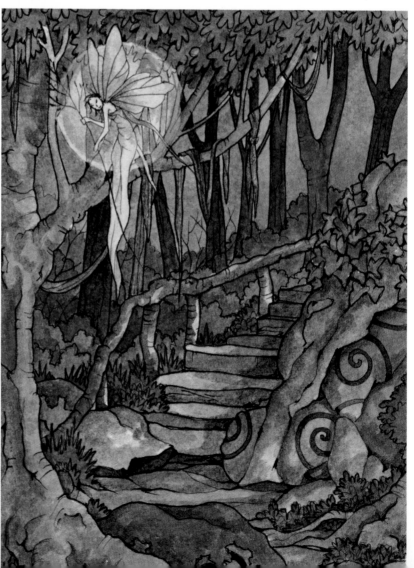

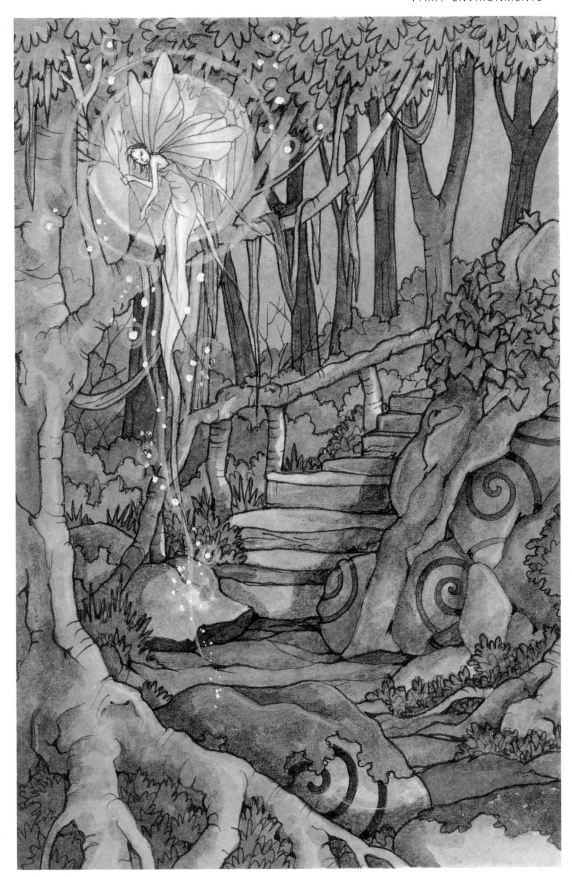

Adding fairy dust

▲ **7.** Using a white-colored pencil, draw a halo around the fairy and add small dots of white gouache to give the illusion of sparkle or fairy dust. Surround some of these little dots with a halo of white pencil, to make them look as though they are glowing as they float around in the air.

Fairy bridges

Ancient fairy bridges (this one is depicted with acrylic paint) are hideaways for fairies. It is bad luck to pass over one of these bridges without acknowledging the fairies that dwell there. Most people write messages and well-wishes on paper and tie them to the trees next to the bridge to secure their safe passage across.

Trace this

1. Trace the fairy bridge template, then transfer it (see page 18).

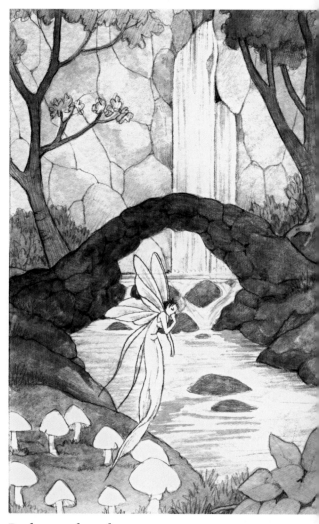

You will need

- HB pencil
- Tracing sheet and graphite transfer paper
- 140–lb. smooth-finish watercolor paper (hot-pressed)
- No. 4 and No. 1 watercolor brushes
- **Acrylic paints:**
 Viridian
 Burnt umber
 Olive green
 Sap green
 Vermilion
 Sepia brown
 Ultramarine
 White

Definition

2. Lightly define the pencil sketch drawn on the watercolor paper—this will remind you where some of the shaded areas will be when applying the paint.

Background washes

3. Using the No. 4 brush, apply very thin washes of viridian to small areas of the rocks by the waterfall at the back of the drawing, together with a few sweeps across the river in horizontal strokes. Apply burnt umber washes to the bridge, riverbanks, boulders, and tree trunks, and apply olive green washes to the grassy banks and treetops.

Glazing

4. By adding more washes you can create deeper colors—this is called glazing. Use this technique with acrylic paints because the colors are waterproof when dry, making it possible to apply wash over wash without disturbing the previously painted areas. Paint more viridian wash over the rocks by the waterfall to instantly add more depth, and brush sap green washes over the riverbank foliage to make it brighter.

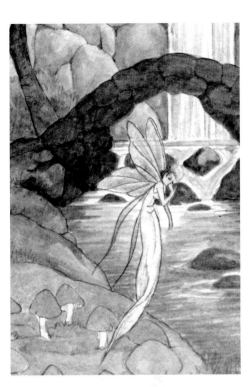

5. Apply a light wash of vermilion to the toadstool ring. Apply more glazes of the previous colors—note that there are more horizontal brush strokes of viridian, together with the addition of sepia brown in the river. Brush a pale wash of ultramarine over the fairy.

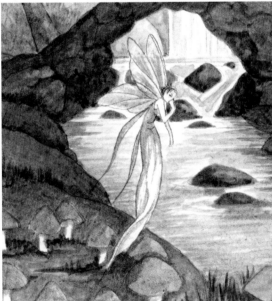

6. Add more definition using the same glazing method. Using the finer No. 1 brush, specific areas can be highlighted and made darker and more defined. Using a sepia brown wash, add shadows around the rocks, the stones on the bridge, and the tree trunks, then a little extra ultramarine to the fairy's gown.

Finishing touches

7. Using the fine brush, complete glazes where needed, and finish the shading with a sepia wash. Using white acrylic paint and the fine brush, add details such as spots on the toadstools and folds on the fairy's gown. The waterfall has been left unpainted apart from a few light wash strokes of viridian, so there is little or no need to add white to highlight this—by allowing the white of the paper to show through, the waterfall is left looking bright and clear, standing out from the background effectively.

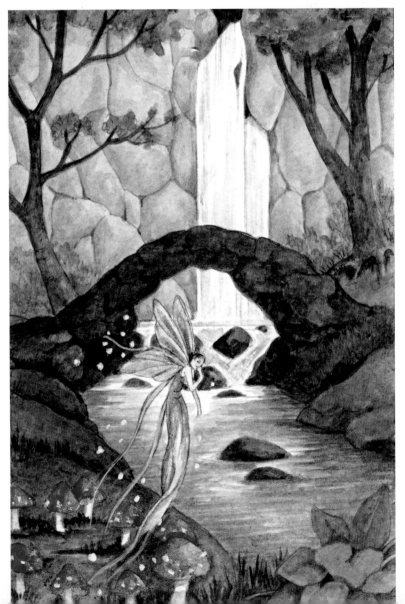

Sacred stones

Standing stones have a magic all of their own. In this project, colored pencils on a tinted paper create a silvery moonlit effect. Tinted and colored paper for pastels and pencils is readily available at art stores.

Trace this
1. Trace the black-and-white image.

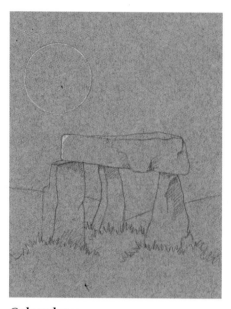

Colored paper
2. Transfer the basic design onto the colored paper using a graphite pencil and use a small amount of white to highlight the moon; this was drawn with the aid of a circular template.

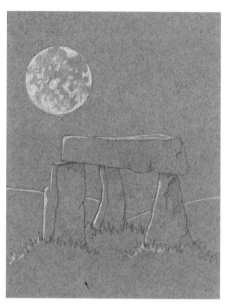

3. Using the white pencil, draw around some of the edges of the stones—this will highlight them and remind you where the moonlight is most likely to fall. Also color in some parts of the moon, and leave gray areas to give the impression of moon craters.

You will need

- HB and graphite pencil
- Trace sheet and graphite paper
- Tinted gray pastel/pencil paper
- Tissues
- **Colored pencils:**
 White
 Dark warm gray
 Cadmium orange
 Ultramarine
 Blue violet
 Pine green (dark)
 Chrome green
 Light green
 Black

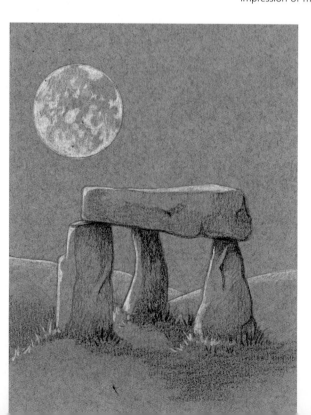

Create shadow
4. Add the darker shadow areas using the dark warm gray—it is easier to understand which areas should be light and which should be dark in the moonlight, which is coming from the lefthand side of the drawing.

Color details

5. Apply cadmium orange to the horizon line to add a warm glow to the the sky. Sketch ultramarine and blue violet across the rest of the sky in long shading strokes, but avoid the moon. Gently blend the sky with the aid of tissue paper and your fingertips.

6. Draw some of the shadier grassy areas using the darker pine green, and add some chrome green as the grass gets lighter in the moonlight.

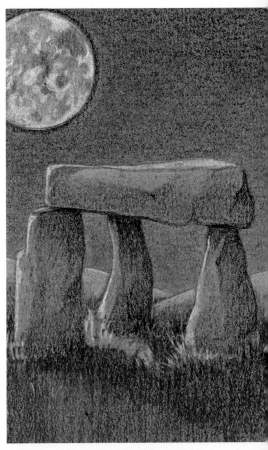

Shadow details

7. Apply light green to the top edges of the far fields, and apply the darker shades to the foreground grass areas. The dark pine green creates deep shadows underneath the stones, making the whole drawing come to life.

8. Draw a halo of white pencil around the moon, creating a blue glow, and highlight the grass with white. Also add small silhouettes of foliage at the bottom using the black pencil.

Foliage details

9. Add more foliage effects using the black pencil, drawing in the silhouette of a tree branch to sweep across the moon, and more grasses in the foreground.

Finishing touches

10. Finally, using a sharp white pencil, draw in the ghostly shapes of fairies flying down to pay homage to the sacred site.

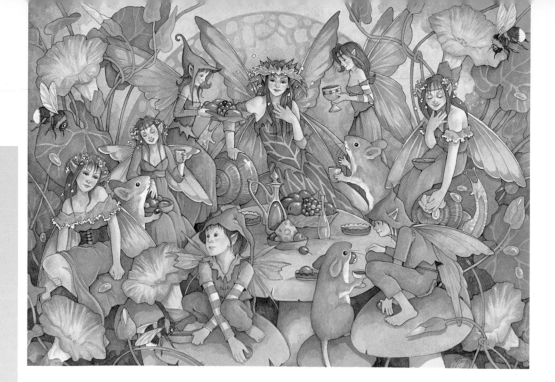

You will need

- HB pencil
- Normal sketching paper for figure cut-outs and sketching (optional)
- Scissors
- Trace sheet with graphite paper for figures and composition (optional)
- .01 sepia waterproof pen
- Eraser
- No. 5, No. 2, and No. 0 watercolor brushes
- No. 30 wash brush (the larger the better)
- 140–lb. smooth-finish watercolor paper (hot-pressed)
- **Watercolor paints:**

 Sepia

 Hookers green

 Purple violet

 Magenta

 Cadmium orange

 Scarlet

 Cobalt blue

 Olive green

 Raw umber

 Cadmium yellow

 Emerald green

 Payne's gray

 Burnt umber

 Ultramarine

 Burnt sienna

 Green gold

 Alizarin crimson

 Carmine

 Black

 Neutral tint

 Zinc white

A midsummer feast

This step-by-step sequence combines elements from several sections of this book to create a colorful scene. Flowers and toadstools form the main shapes for this composition, then the figures, animals, and juicy berries provide the ornamentation—the scene is easy to compose if you study it.

This project is a springboard for your own ideas—do not try to trace the image. You can use as many or as few figures as you wish—a small picnic with just two or three fairies would be just as colorful.

To create your own version of *A Midsummer Feast*, make some sketches of flowers, foliage, insects, and other elements you wish to include in your composition. You can use photographs as inspiration for the fairy figures. However, if you don't want to draw your own figures or if you find them too difficult, you can trace and use some of the ideas from the ready-to-draw figure guide on pages 120–125. Although there is a large list of watercolor paints here, you don't have to use them all—I encourage you to add your own artistic flourishes.

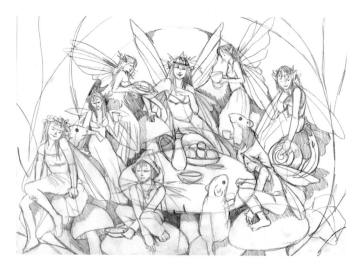

Rough sketch

Using the HB pencil, draw a rough sketch marking out your toadstool table as the central object. With the surrounding seated figures, the overall shape of the composition is circular and is pleasing to the eye.

Sketching tip

If you find it difficult to work out where your fairies should be, a good tip is to cut out your sketches into individual pieces and move them around the page until you are happy with the general composition, then trace over the whole composition. Then re-draw it onto your watercolor paper. With practice you will soon be able to compose your own drawings without the cut-outs.

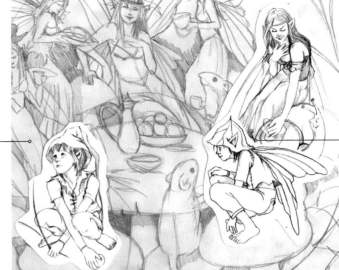

Move cutout sketch until you are happy with the composition.

See how figure overlaps work.

Background detail

Add more detail to the figure shapes, and sketch in morning glory flowers for the background—nice trumpet-shaped flowers that are quite easy to draw (not too many petals).

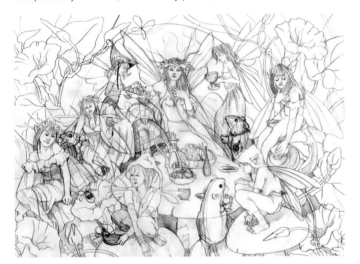

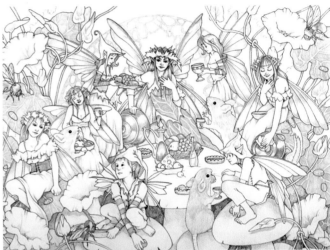

Figure details

Using the sepia waterproof 0.1 pen, draw in all of the detail, then remove the pencil lines with the eraser. Add pencil shading to the leaf garments and background. Note: you can add extra elements such as the bumblebees in front of the morning glory flowers, but only before you draw in the sepia ink lines.

Background washes

Apply a very dilute wash of sepia to the entire drawing with the large wash brush, allowing this to dry completely before continuing. Add deeper washes of sepia using the No. 5 brush, creating all the shadows and defining the entire drawing, then create the deep shadows in between the plants. This sepia wash should get gradually lighter from the bottom to the top of the image.

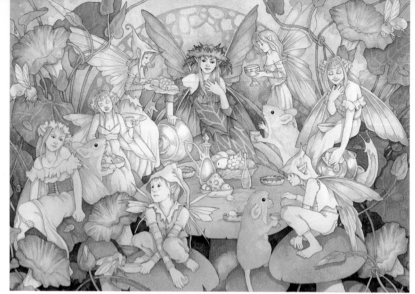

Background washes ▶

Using the No. 5 brush, apply color washes to parts of the background as follows:

Morning glory vine leaves Hooker's green
Flowers Purple violet and magenta
Fairy queen's gown Purple violet and magenta
Setting sun Cadmium orange, scarlet (while orange wet)
Around the queen Thin cobalt blue wash, blending to sides
Background foliage highlights Olive green
Toadstools Heavy wash of raw umber

Fill in the color ▶

Adapt this part of the painting with your own color washes. The following is a guide to the main parts of this color scheme. Use a No. 5 brush for large areas and a No. 2 for smaller ones.

Setting sun Cadmium yellow
Fairy wings 1, 2, 5 Cadmium yellow
Pixie wings 6 Cadmium yellow
Fairy wings 3, 4 Washes of Hooker's green
Pixie wings 7 same as above
Gown for fairy queen Purple and magenta
Fairy 1 gown Ultramarine
Fairy 2 gown Scarlet with alizarin crimson
Fairy 3 gown Purple violet, emerald green
Fairy 4 gown Scarlet red and emerald green
Goblet Payne's gray
Fairy 5 gown Ultramarine
Pixie 6 cap and shirt Hooker's green
Pixie 6 jacket Scarlet
Pixie 6 trousers Burnt sienna
Pixie 7 cap Hooker's green
Pixie 7 shirt green gold
Pixie 7 trousers burnt sienna
Snails Light washes of burnt umber
Mice Heavy washes of burnt umber

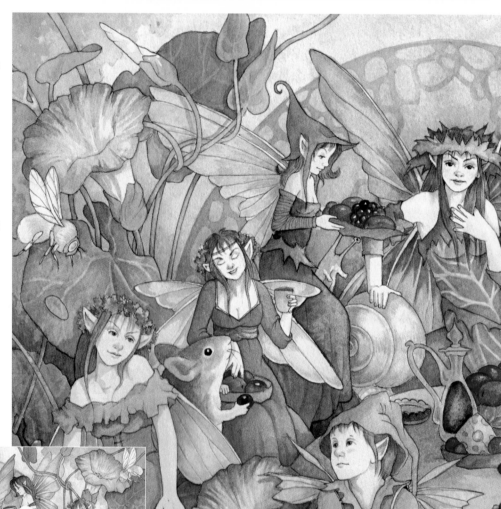

Elegant details ▷
Use brush No. 2.
Red berries Scarlet and carmine
Blackberries Alizarin crimson and a little black
Pitcher handle Payne's gray
Glass Wash of cadmium yellow with emerald green added while the yellow is still wet, allowing the colors to run together.

Light and shade ▽
With the No. 2 brush, add some cadmium yellow and dark neutral tint to the bumblebees. Still using the same brush and the neutral tint, continue to add definition and shading—the light source is on the righthand side, therefore items positioned to the left will be darker.

Paint in the shading on the lefthand side—the figures to the right should be pale and not as defined.

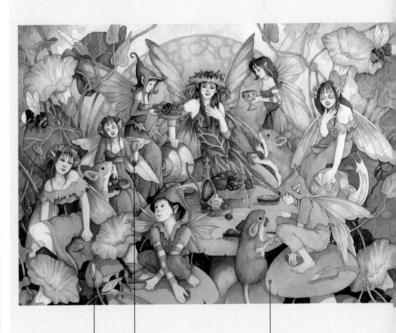

Shading has been applied to the areas of foliage to create a 3D effect and create more image depth and dimension.

More shading has been done on the figures' clothing in order to make them pop off the page.

On this side of the painting, the images are still flat and undefined. With shading, this side will come to life.

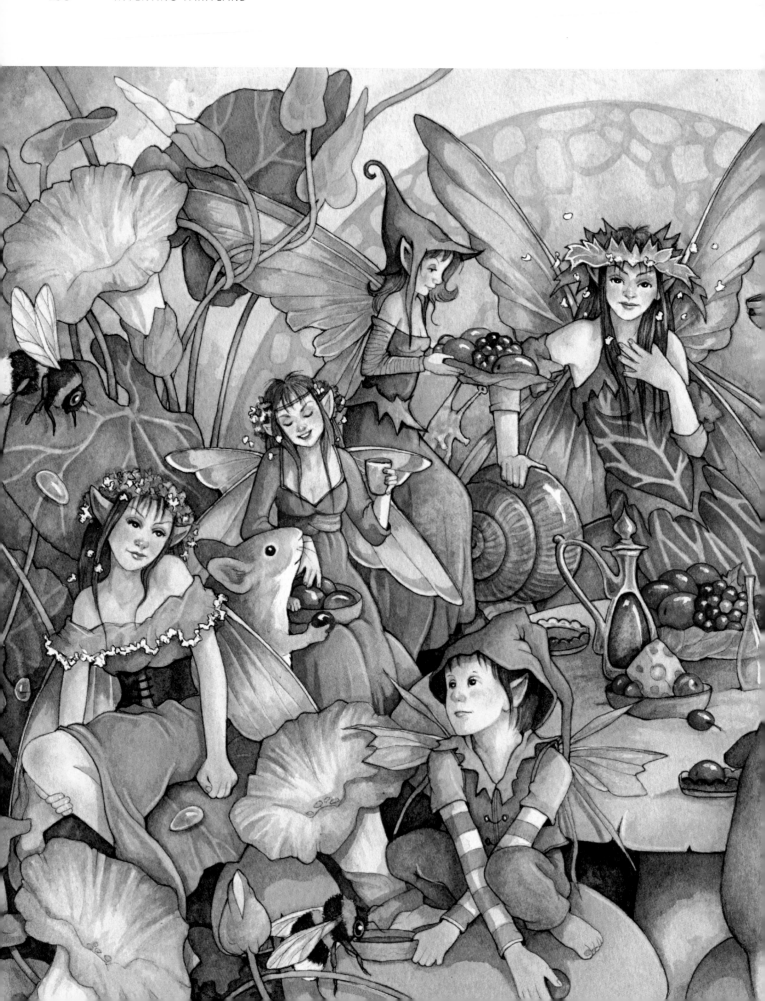

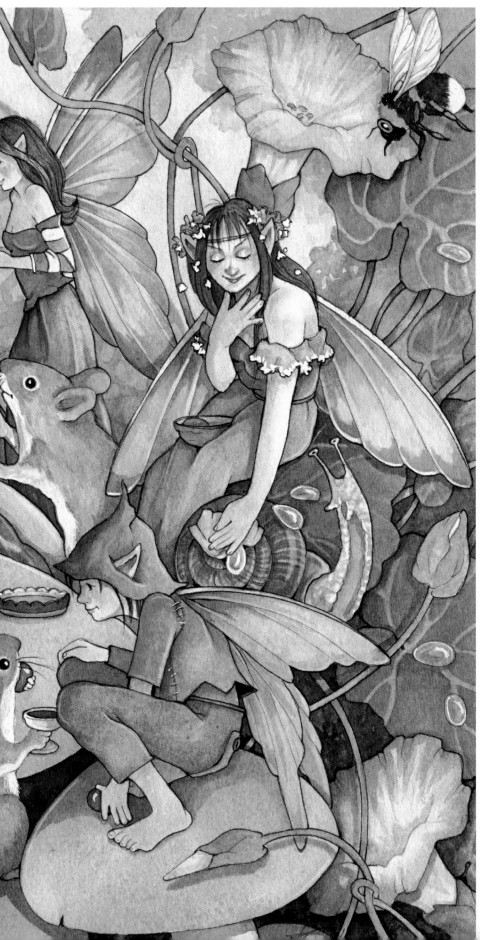

Finishing touches

Keep applying your final touches, adding a little extra depth here and there with washes. Use a little black with the No. 0 brush on the bumblebees if you wish to make the figures stand out more; to add more intensity and depth, re-draw the entire image with your sepia 0.1 pen.

Once you are happy with your painting, you can add the final touches. Using plenty of well-mixed zinc white and the No. 0 brush, add little sparkles to the dewdrops, berries, and glass, a little white fur on the mice, highlights in all of the eyes, then some frothy lace and flowers to the fairies and their gowns.

Insect details
Use white for the bee's bottom, and black and cadmium orange for the body. A dot of white makes the eye shine.

Berries and glassware
White highlights capture the reflective qualities of glass.

Gown details
Use white for the detailing on the dress and the headdress, and for the highlight in the dewdrop.

Fruit details
White highlights make the tray of fruit sparkle.

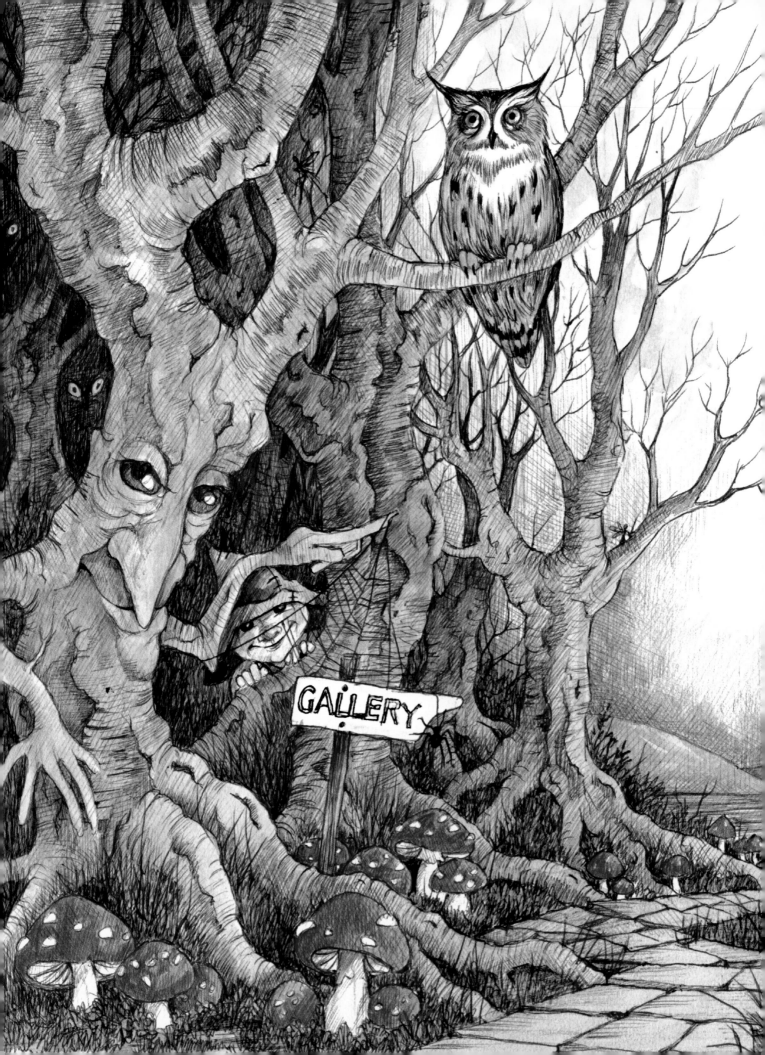

Chapter 4

Gallery

This wonderful array of fairyland art is by some of the most eminent fairy artists specializing in this subject throughout the world today. Enjoy this selection of inspirational images, and use some of their magic when you create your own paintings.

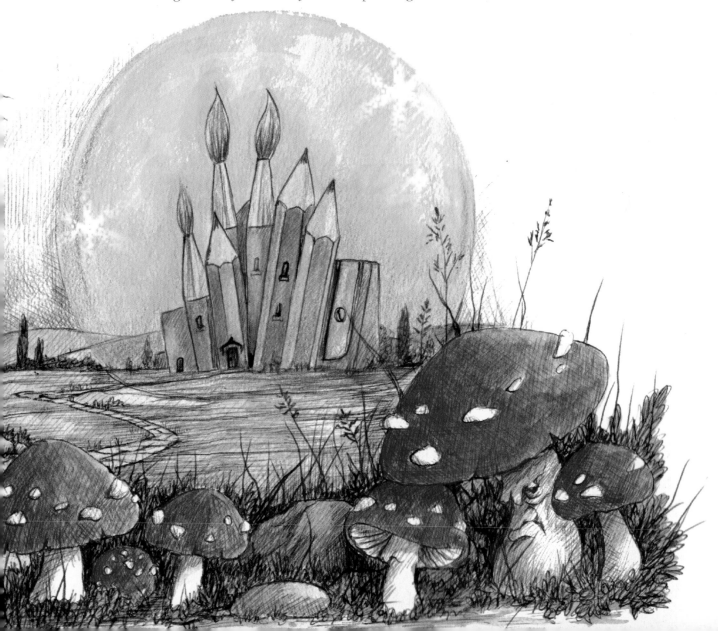

Faery Moon

Suzanne Gyseman

Subtle tints of watercolor wet-into-wet and colored-ink washes are used on watercolor paper to create this eye-catching painting. Spatterings and splashes of colored inks are dropped onto the picture with a pipette, and blown with a straw after the first washes are dry. The three colors used are located beside each other on the color wheel (an analogous color scheme: yellow [ocher], [olive] green, and [turquoise] blue). Hatching (fine short lines) and stippling (fine dots) techniques are used with a fine, black, technical pen (0.1 nib) once the background is dry.

Early Spring

Kajsa Flinkfeldt

This watercolor painting started as a photographic reference of a favorite landscape location. Yellow and gold ocher, cadmium and Indian red, Payne's gray, cerulean, cobalt, and Prussian blue are just some of the colors used throughout. By painting wet-on-wet and wet-on-dry in many layers, the artist achieves a beautiful smooth finish. White gouache is used for highlights and accents.

Titania and Bottom (from *A Midsummer Night's Dream*)

Nicole Pisaniello

In this classic fairyland scene, Shakespeare's Titania hovers with Bottom on her fairy bower while her bewildered servants look on. The painting is full of exciting movement and detail. If you look carefully you can see Puck peering through the foliage.

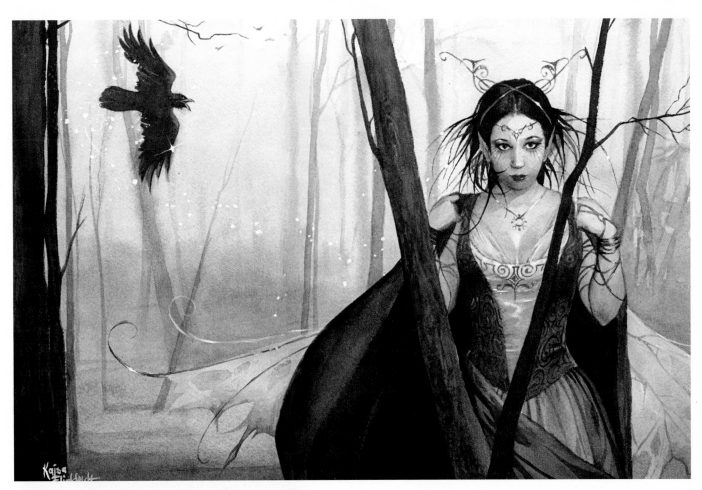

Raven Faery

Kajsa Flinkfeldt

A portrait of a friend as dark, woodland fairy, this watercolor painting is dominated by red, ocher, and sepia tones on 185g, cold-pressed watercolor paper. The artist favors white gouache for her accents and highlights, and works wet-on-wet and wet-on-dry in many washes.

Forest Dragon

Suzanne Gyseman

I love the use of the colors in this piece. The dragon, insects, and other wildlife merge with the foliage so that they almost appear camouflaged. If you blink they might just vanish into thin air, keeping their secret hidden within the forest.

Fairyland

Sue Miller

This fairyland painting was created in watercolor (on 300-lb. paper), with the addition of acrylics for an injection of vibrant, opaque color (used, for example, on the flowers). A fine-line permanent marker in dark green created the grass outline (the longer grasses were made with a liner brush). A salt technique was used on the background while wet, and a toothbrush used for spray and spatter effects with white watercolor for the fairy dust. The interesting circular composition was achieved by hand with a compass.

Daydreamer

Meredith Dillman

This image uses a complementary color scheme in Payne's gray, sap green, quinacridone red, Indian red, burnt sienna, lamp black, burnt umber, cobalt, and terre verte for the muted green in the background. It was worked wet-on-dry (allowing each layer to dry before adding more color) in many layers with some color glazing. White highlights are spattered on some of the trees and over the forest to add a magical quality. Working from a photographic reference for the figure, Meredith used a dip pen with a small 108 or 107 nib and waterproof ink for the lines on the figure and foreground before paint was applied.

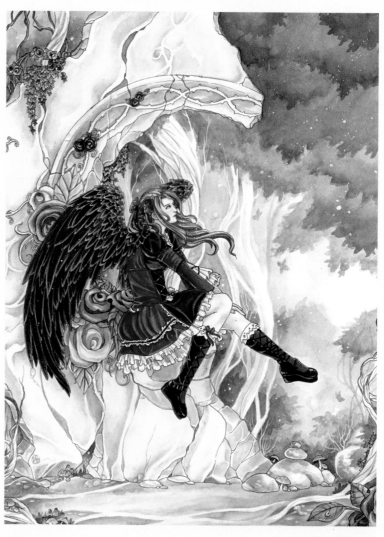

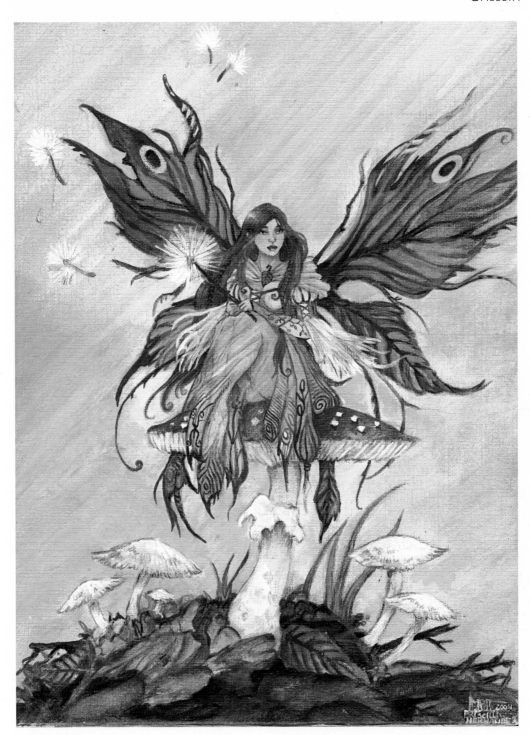

Autumn Fairy

Priscilla Hernandez

In fairyland, fairies and toadstools just seem to go together. Using acrylics as if they are watercolors, Hernandez blends very diluted layers of washed acrylic paints in crimson red, burnt umber, and yellow ocher over the top of one another. She uses brown ink to make her final lines, and adds patterns with a sharp, ivory-colored pencil.

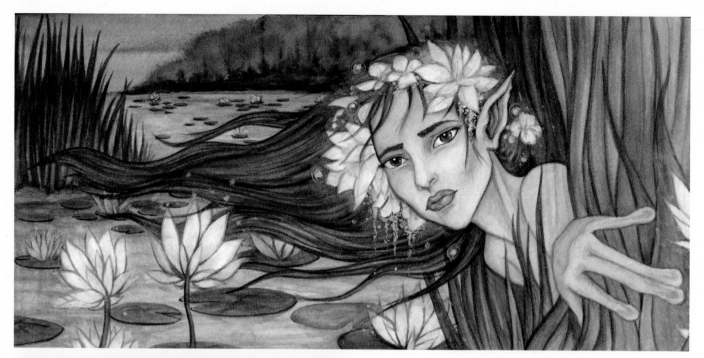

Water Lily (above)

Nicole Pisaniello

A water nymph peers through the rushes in this painting, an example of how few colors are required to create a special feeling. I love that her skin is the same shade as the murky water in which she lives, and that the white tips of the water lilies stand out in the gloom, leading the viewer's eye.

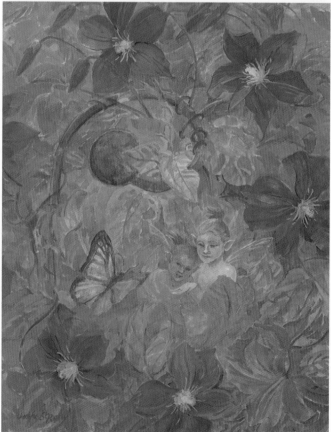

The Visitor

Wenche Skjöndal

In this painting, vibrant shades of blue and violet in the clematis flowers are a perfect contrast to the yellow green leaves that surround them. The petals create an oval shaped bower, framing a home for the almost invisible fairy figures who are greeted by the Yellow butterfly. Flowers and foliage make excellent fairy landscapes and are accessible subjects.

Giving a Hand in Fairyland

Myrea Pettit

Although it is a dirty job, and one of the more mundane elements of fairyland, sweeping out the chimney pots has got to be done! Using a black-ink pen and colored pencils, Myrea achieves her glowing berry colors with a sharp colored pencil and a light blending hand. Her complex composition depicts a number of focal areas (including the chimney sweep perched on the roof of a fairy mushroom home) all within the balanced arrangement of the pretty flower and berry border.

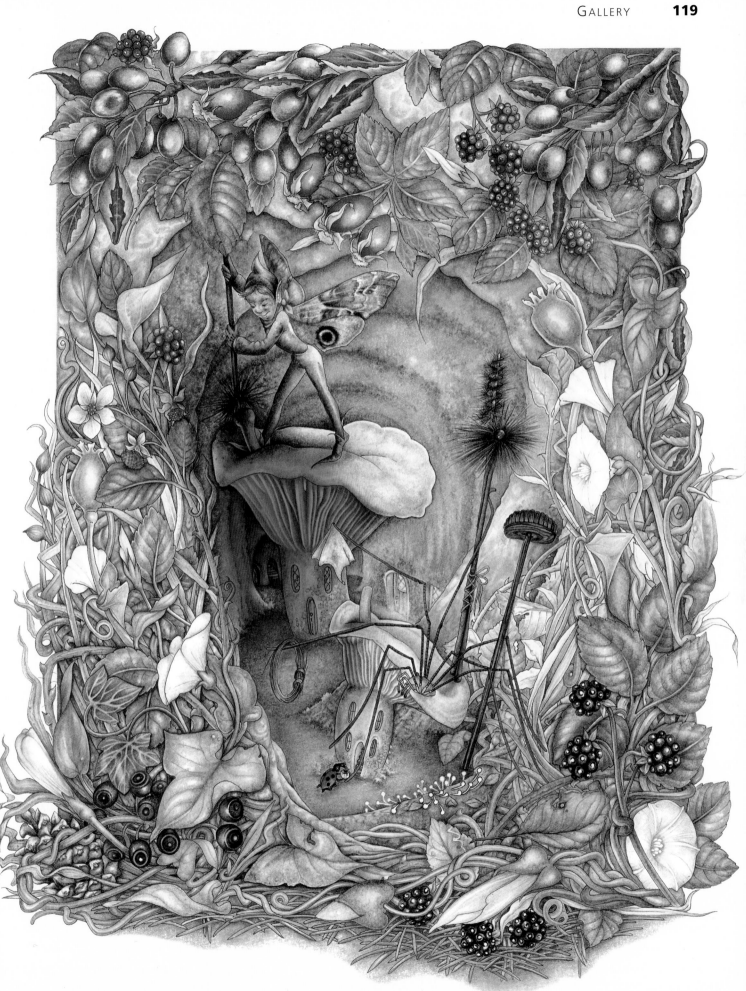

Ready-to-draw file:
Figures

This is a selection of ready-to-draw and trace figures; you can use them to compose your own fairyland scenes or to re-create some of the projects in the book. They should be quite useful to those of you who are still a little nervous about drawing figures.

I have included the fairy queen and her handmaiden from the midsummer feast project (pages 104–109) and a few other small fairies and pixies, which you could use to re-create your own version of the midsummer project. You will also find some small baby characters which are very simple to draw. If you find faces difficult to paint, draw little caps and hats on your fairies so that you can hide some parts of the face; also, if you find legs and feet awkward, simply create a long gown to cover them.

Remember that you can always alter the looks of these fairies by changing the hairstyle or clothing to suit your own ideas. I hope you enjoy playing with them!

Imaginative adaptations
Consider adapting and changing the fins and tail by referencing real-life aquatic animals like frogs.

Simple shapes
A very basic head, torso, and arms, the rest of this fairy is composed of simple flowing lines.

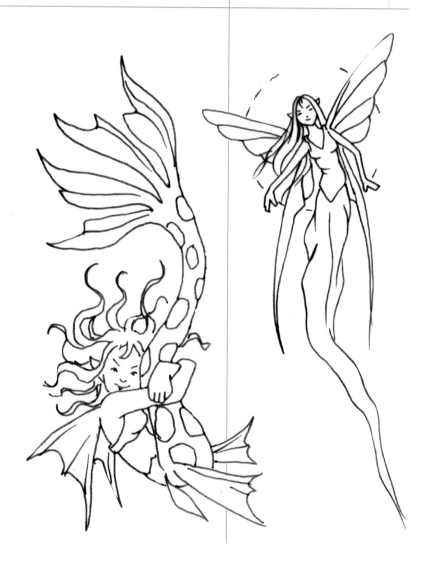

Model photographs

Use photographic references whenever possible for realistic expressions and natural poses. Ask a family member to model for you, or cut out pictures from fashion magazines.

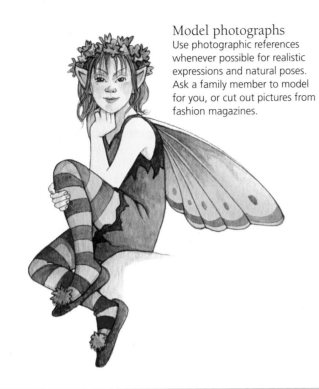

Fairy clothing

Fairy clothing can be modeled on our own clothing; however, keep in mind the materials from which their fairy clothes are created. Scraps and found patchwork remnants are the most likely materials out of which fairies construct clothing.

Color camouflage

Use greens and browns and forest colors for fairy clothing. Why is it there aren't more fairy sightings? Obviously because the fairies are all suitably camouflaged against prying human eyes against their traditional backgrounds of woodlands or forest glade.

Color changes everything

The Ice Queen can be radically changed with a complete color makeover. Move her dramatically from winter to summer, from Ice Queen to May Queen, with the use of cadmium yellow, Indian red, and vermilion. Change her icicle scepter to a staff of climbing flowers.

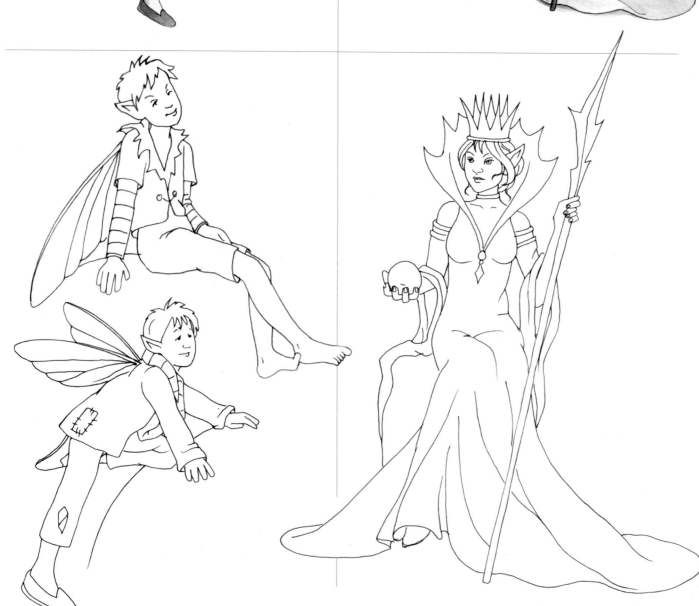

Old and young fairies

Remember to create a variety of fairies (and their close relations) when populating fairyland. Diversify your fairy folk to ensure a realistic range of ages.

Simplifying shapes

These simplified fairy children have been designed for ease of transfer. The side view of this baby in pink, for instance, makes her easier to draw for those who have problems with features. Remember to simplify and adapt your own designs to suit your growing range of skills.

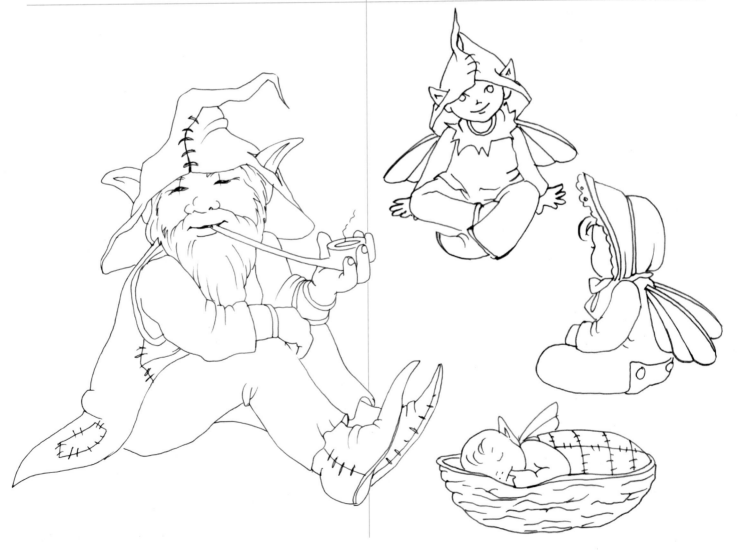

Color scheme considerations

Choose the colors of your fairy in accordance with the mood of your painting. Should the fairy match her surroundings and blend in, or should she be dressed in a vivid, contrasting color and stand out as the main focus of the piece? Take a look at the color theory and application section (pages 20–21) to make your color scheme decision.

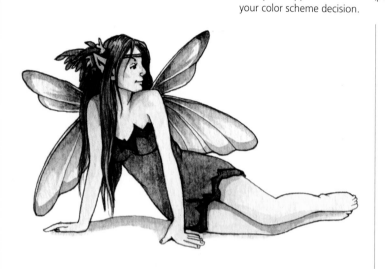

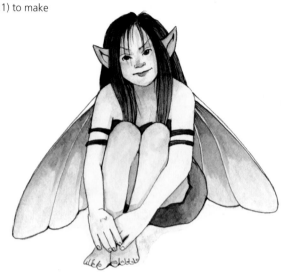

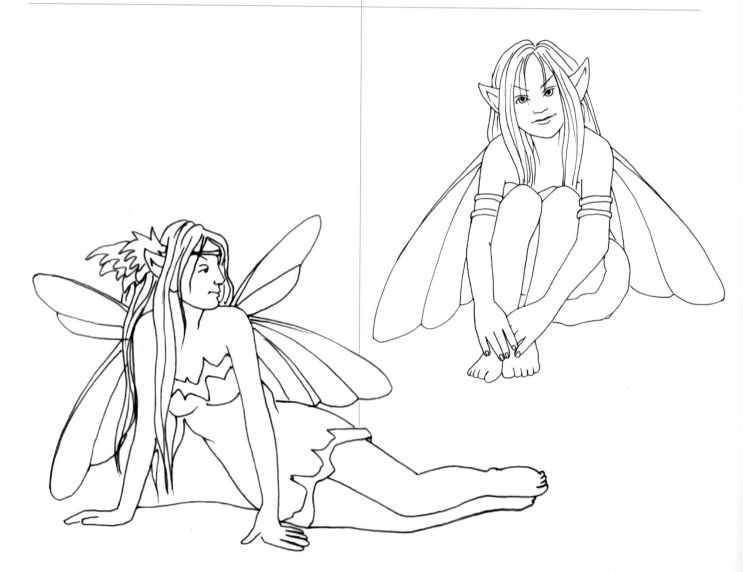

Nature reference

These fairies both have large, butterfly-style wings. Take them one step further to make them your own, and transform their wings by looking at photographs of butterflies in nature magazines.

Colorful patterns

Trace this template, then update it with your own twist on the patterns in her dress. Her striped bodice and skirt could be covered in polka dots!

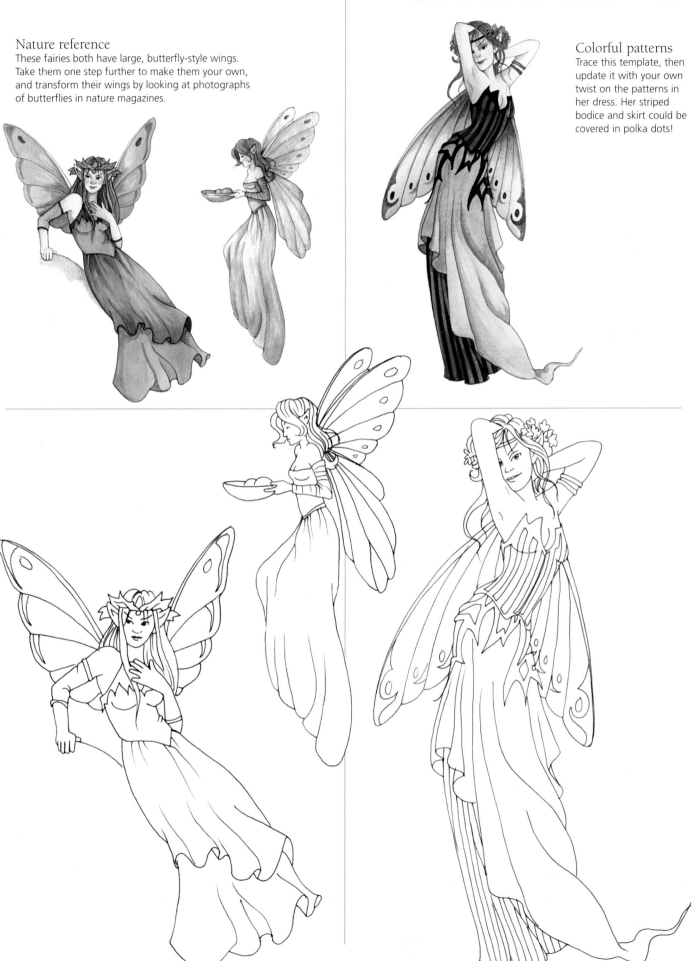

Index

A

acorns 69
acrylic paint 14–15
 techniques 60
Andersen, Hans Christian 84
animals 44–45
anthropomorphisms 52–53
apples 68

B

berries 70–71
blackberries 71
blending 60, 83
 pen 17
branches, winter 67
bridges, fairy 100–101
brush and ink 17
brush over wet paint 59
brushes
 acrylic paint 14, 15
 gouache 13
 watercolor 12

C

castles
 in fairyland 86–87
 in the air 82–83
 thrones in ice castles 84–85
cherries 70
clouds 24, 25, 83
cobwebs 82
collections 32, 52
color wheel 20, 21
colors
 complementary 21
 creating moods 28–29
 harmonious 21
 primary 20, 21
 secondary 20
 temperatures 21
 tertiary 20
composition 36–37
craft knife 10
crayons, wax 16
 resist 17
cropping 38
cross hatching 92, 93

D

depth 46, 70, 71, 72, 76, 80, 83
Dillman, Meredith: *Daydreamer* 116
dragons 50–51
dry brush on wet 60
dry brushing 15, 58
Dulac, Edmond 84

E

erasers 10

F

fairy bridges 100–101
fairy dust 99
fairy glow 98
fairy groves 96–99
fairy neighborhoods 54–55
fall (autumn) 27
feast, midsummer 104–109
feathering 12
feathers 74
fences, wood 80
fiber tips, colored 16
figures 120–125
Fitzgerald, John Anster 44
fixative 10
flat wash 14, 58
Flinkfeldt, Kajsa
 Early Spring 113
 Raven Faery 115
flowers 22–23, 72–73
fog 25
foliage 23, 64–65, 103
foreshortening 43
form, three-dimensional 46
frost 66, 85
fruits and nuts 68–69
fungi 94–95

G

gallery 110–119
glazing 12, 15, 101
granite rocks 77
grids 19
groves, fairy 96–99

Gyseman, Suzanne
 Faery Moon 112
 Forest Dragon 115

H

Hernandez, Priscilla: *Autumn Fairy*
 117
highlights 11, 13, 23, 60, 63, 66,
 68, 70, 71, 75, 79, 89
homes, fairy 48–49, 82
 fairy bridges 100–101
 fairy groves 96–99
 fairy tree homes 92–93
 mushroom villages 94–95
horse chestnuts 69
hybrids 53

I

imagination 31, 32, 34, 38, 50, 92
impasto 14
impressing 59
inks 11, 13, 16, 17
 ink and paintbrush 11
 ink and wash 11
 ink wash with highlights 11
insects 44–45
inspiration 31, 32–33, 92

L

layering 12
leaves 22, 65–65
 frosty 66
letting color in 12
lifting out 14, 58
light and shade 46–47
light over dark 13
lost-and-found edges 12

M

man-made world 80–81
markers 11, 16, 17
masking film and stipple 61
masking fluid 12, 60
masking paper 18
midsummer feast 104–109
Miller, Sue: *Fairyland* 116

mirror 36
 image 78
misty scenes 25
monochrome media 10–11
moods, using color to create 28–29
mottling 12
mushroom villages 94–95

N
nature 32, 50
 details 62–63
nuts, fruits and 68–69

O
oxgall 13

P
paint
 acrylic 14–15
 distressed 15
palette knife 15
palettes
 acrylic paint 14, 15
 watercolor 12
papers
 acrylic paint 14
 colored 102
 graphite pencil work 10
 pen work 11
 torn paper 13
 watercolor 12
pastels 16, 17
 pastel mix 60
 techniques 60
pebbles 76
pen and brush tone 17
pencils
 accessories for 10
 colored 16, 17
 graphite 10
 marks 10
 pastel 16
 water-soluble 16
pens 11
 marks 11
 types of 11
perspective 37, 42

Pettit, Myrea
 Giving a Hand in Fairyland 119
photography, reference 22, 33, 92, 96
Pisaniello, Nicole
 Titania and Bottom 114
 Water Lily 118

R
rain 25
rainforests 90–91
recycling 54
reference library 32
reflections 78
retarding medium 14
ripples 79
rocks, granite 77
rosehips 70

S
sacred fairy places 40–41
sacred stones 102–103
sand 15
sandpaper block 10
scale 39
scalpel 10
seasons 26–27
seedheads, fluffy 75
sgraffito 60
shading 62, 66, 69, 70, 72, 79, 83,
 85, 92, 93, 107
shadows 67, 69, 75, 79, 87, 92,
 102, 103
sketchbook 32, 33, 34–35
Skjöndal, Wenche: The Visitor 118
sky effects 24–25
spatters in wet paint 58
springtime 26
standing stones 102–103
stippling 77
summertime 27

T
texture media 13
texturing agents 15
thickening gels 15
thrones in ice castles 84–85
toadstool "fairy" rings 40, 41

toadstools 94, 95
tracing images 18
transferring an image 18–19
transformations 50–51
translucency 75
trees 62–63
 fairy tree homes 92–93

U
underwater 88–89

V
variegated colors 58
viewpoint 36, 37

W
walls, stone 81
wash
 using fine salt 59
 using large crystals 59
water sprites 88
watercolor 12, 13
 techniques 58–59
wax crayons 16
 resist 17
weather, fairyland 24–25
wet-into-wet 14, 58
wet-on-dry 13
winter 26, 66–67
workspace 32

Credits

Quarto would like to thank the contributing artists for kindly supplying illustrations reproduced in this book.
Artists are acknowledged beside their work. All other photographs and illustrations are the copyright of Linda Ravenscroft or Quarto Publishing plc. While every effort has been made to credit contributors, Quarto would like to apologize should there have been any omissions or errors—and would be pleased to make the appropriate correction for future editions of the book.

Any illustration not credited to an artist on the page where they appear is the work of Linda Ravenscroft, who can be contacted at www.lindaravenscroft.com or by email at linda@ravenart.fsnet.co.uk.

Author's acknowledgments
Dedication
For my mother and father who inspired my whole life with love and magic!
Thank you to all the wonderful artists for allowing me to use their inspiring images in this book. Also thanks to my dear husband, John and daughter, Vivien (my beautiful fairy muse and model), to Angi, Silas, Merni, and Kim at Duirwaigh Gallery, Kim and Mary at *Faerie Magazine*, and dear Bee. "Kubiando" to you all! And, to a very special young lady: H.R.H. Faerie Queen Rose Petal, a.k.a. Aimee Butler and her mom, Rosie, who run the Fairy Box charity in the UK (www.fairybox.org).

Fairies are Nature's guardians, the enchanted keepers of our fears, hopes, and dreams. Whether you believe in them or not, they still have a place in our modern-day society, and their light is needed now more than ever before! I hope that you find your own "fairyland" in which to paint your dreams.

Shine brightly,
Linda Ravenscroft

Artists' websites
Meredith Dillman
www.meredithdillman.com

Kajsa Flinkfeldt
www.flinglingart.com

Suzanne Gyseman
www.suzannegyseman.co.uk

Priscilla Hernandez
www.yidneth.com

Sue Miller
www.suemillerart.com

Myrea Pettit
www.fairiesworld.com